M000239998

IMAGES
of America

RAMONA

ON THE COVER: Taken in 1890, this image captures the Bollman Store, family members, and customers on Main Street Ramona. (Guy Woodward Museum.)

IMAGES
of America

RAMONA

Richard L. Carrico

ARCADIA
PUBLISHING

Copyright © 2011 by Richard L. Carrico
ISBN 978-0-7385-8162-0

Published by Arcadia Publishing
Charleston, South Carolina

Printed in the United States of America

Library of Congress Control Number: 2010934480

For all general information, please contact Arcadia Publishing:
Telephone 843-853-2070
Fax 843-853-0044
E-mail sales@arcadiapublishing.com
For customer service and orders:
Toll-Free 1-888-313-2665

Visit us on the Internet at www.arcadiapublishing.com

*This book is dedicated to Jennifer and to all the families
who have made Ramona a special place for all of us.*

CONTENTS

ACKNOWLEDGMENTS

The author thanks the Guy B. Woodward Museum and its dedicated director, Kenneth Woodward, for agreeing to collaborate on this project and for providing access to the treasure trove of historical photographs and documents that the museum houses. Many towns and communities have wonderful local museums and historical societies, but Ramona is particularly blessed to have the facilities, buildings, and archives that tell the story of this very special place.

All photographs in this book are from the Guy Woodward Museum collections unless otherwise cited. The assistance of Chris Travers of the San Diego History Center (SDHC) was instrumental in obtaining photographs from their extensive and well-catalogued archives. The San Diego Museum of Man supplied some early images of Mesa Grande (SDMM). Johnny MacDonald (MAC) and Andy Smith provided information and photographs regarding the importance of Ramona in early hot rods and drag-car racing. Kevin Cantrell, Jerry Cantrell, and Dave Schneider of Schneider Cam (SC) allowed me to reproduce images of Ramona's San Diego Raceway. Family photographs, recent photographs, and information were also provided by Sam Quincey (SQ), Ken Woodward (KW), the California Division of Forestry (CDF), Cris Tolley (CT), San Diego Hall of Champions (SDHC), and Gertrude Wilson Page (GWP). Richard L. Carrico (RLC) provided several early documents and photographs.

Historical research was greatly aided by local historians and authors Darrell Beck and Chuck Le Menager. Lee Bibb provided helpful insights into roads, trails, and old adobes, not to mention the movement of Stephen Watts Kearny. Susan Bugbee and the late Kathleen Flanigan left a wonderful trail of historic research, nuggets, and insights that aided my trip through the uneven terrain that is local history. As in almost everything that this author writes, there is a debt of gratitude to local tribal members, including David Toler and the late Dorothy Tavui of the San Pasqual Band of Mission Indians, and Mark Romero of the Mesa Grande Band of Mission Indians. All writers need good editors, not only to edit, but also to prod and cajole. Debbie Seracini at Arcadia Publishing excelled in all three of these tasks, and for that I give thanks.

INTRODUCTION

Home to San Diego's first people—the 'Iipay and Kumeyaay tribes, the "Valley Above the Fog and Below the Frost," a place where rodeos still reign, "Valley of the Sun," turkey capital of the world, the "Heart of San Diego County," and present-day community with a foot in the rural past and one in the emerging future, Ramona has been all this and more. With its roots deep into the prehistoric past, Ramona, and the Santa María Valley that surrounds it, can be fairly said to be one of the oldest continuously occupied areas of California.

According to archaeologists, more than 9,000 years ago people migrated into what is now the broad and wide Santa María Valley. The 'Iipay and Kumeyaay tribes' name for the Santa María Valley is Matartay, or "long valley." Today, many of the descendants of these ancient people live within the greater Ramona community, on the nearby Mesa Grande and Santa Ysabel Reservations, and on the San Pasqual Reservation in Valley Center.

The historic period in Santa María Valley began in 1778, when a military expedition was sent to the powerful 'Iipay village of Pa'mu to harass tribal members. The next Spanish entry into the area was almost two decades later, in 1795. In that year, Fr. Juan Mariner and Captain Grijalva led a scouting party from the San Diego presidio in search of a potential mission site. Santa María Valley was abandoned as a possible mission site in favor of the *asistencia* (a "sub-mission") built at Santa Ysabel. Instead, a large land grant comprised of 17,708.85 acres in the valley served as far-flung grazing grounds for livestock from Mission San Diego.

In 1833, a Mexican soldier named Narciso Botello received the Santa María land grant. Unable to successfully ranch the land, Botello abandoned it, and in 1843 the grant passed to Jose Joaquin Ortega and his American son-in-law, Capt. Edward Stokes. During this time, the valley became part of the travel route connecting the backcountry to San Diego.

Over the next 30 years, the Santa María land grant stayed in the Stokes family, and Edward Stokes's three sons—Alfredo, Adolphus "Adolfo," and Eduardo—built several adobes on the Rancho Santa María, including the Adolfo Stokes adobe that still stands east of the intersection of Highway 78 and Magnolia Avenue. Another adobe (often noted as a Stokes adobe, but actually the Etcheverry Santa María adobe, destroyed several years ago) was located north of Highway 67 near Hope Street slightly north of Highway 67. This adobe was where Stephan W. Kearny camped before moving on to the Oak Grove camp off Highland Valley Road and then on to defeat in San Pasqual Valley. This adobe is often confused with the Edward Stokes adobe at Santa Ysabel, where Kearny had also camped after moving south from Warner's.

With the capitulation of Mexico in 1848, California became a territory of the United States, and the American period of Ramona's history dawned. When they left the US Army in 1854, Samuel Warnock and Joseph Swycaffer ran mule trains carrying mail and supplies between San Diego and Yuma. Their travels took them through the Santa María Valley, and they realized its potential. Warnock homesteaded first, filing his claim in 1857 within the Ballena Valley. In 1859, William Warnock followed his brother west and homesteaded Santa Teresa Valley. His home remains the oldest standing adobe in the area.

Adolfo Stokes married his half-sister Dolores Olvera and returned from Los Angeles to the Santa María Valley to live. Having ultimately bought out his brothers, Adolfo sold virtually all of the Rancho Santa María to Juan Arrambide 1872. Adolfo, however, retained 1,000 acres in the fertile and beautiful Goose Valley (Valle de los Amigos).

As Juan Arrambide consolidated his holdings within the Rancho Santa María, a French immigrant, Bernard Etcheverry, arrived in San Diego. Etcheverry obtained a large tract of land at the western end of Santa María Valley. Within a few short years, he and Arrambide were grazing large flocks of profitable Merino sheep and harvesting dry farmed barley. Etcheverry constructed a large adobe hacienda that stood near Highway 67 until 1934, when it was razed. Known as a fair and generous man, he encouraged sharecroppers and workers to work the land and settle in the valley.

In the 1870s, the backcountry of San Diego witnessed a gold rush that spawned the communities of Julian, Banner, and Ballena. Ballena (Spanish for "whale" and meant to reflect the 'Iipay word for whale, 'epank, for the same valley) thrived as a layover point and provided fresh teams of horses and mules for freight wagons hauling gold to National City and supplies from San Diego. In 1870, Sam Warnock opened a general store and post office at Ballena to serve the community.

Two years later, Daniel McIntosh retired from a maritime life and settled on land between Ballena and the Santa María Valley, on the west. Recognizing an opportunity, he built an adobe and operated a stage station for travelers along the Barona-San Vicente Trail. A little east of Ballena, Frederick Sawday moved his freight wagon business from Julian to Witch Creek in 1881; his son George is credited with developing the cattle industry in the area in the 1890s. Further to the west, M.C. "Doc" Woodson, a dentist from Kentucky, homesteaded at the foot of a prominent mountain landmark that later took his name. Within a few years, Doc Woodson gained a reputation as a gardener, orchardist, and unequalled grape grower. Woodson's honorable past as a Confederate soldier, coupled with his wines, made him a friend to even the most dedicated Unionist.

With all of the ranches, farms, and homesteads stretching from western Santa María Valley into the eastern hills at Witch Creek, it was natural that a town would rise from the soil to serve the people. Bernard Etcheverry offered an invitation to a fellow Frenchmen and his son, Theophile and Amos Verlaque, to visit the valley. Theophile, who was known for his stores and wine shops in downtown San Diego, probably saw the opportunity for his son to get a stake in the growing backcountry. Amos started with a two-acre parcel on the main dirt road, constructed his Santa María Store on the north side of the road, and volunteered space for the first post office, which was named Nuevo in 1883 (the town would not be renamed Ramona until years later). Ultimately Amos's brother Jeff took over the business and changed the name to the Pioneer Store, and the building stayed in the family until 1933.

Not to be outdone by his enterprising sons, in 1886 Theophile Verlaque built what he called his country home next to his son's store. Mrs. Leona Ransom purchased the home, with its distinctive verandah and French plantation-style overhanging roof, in 1962. In 1984, the Ransom family donated the house to the Ramona Pioneer Historical Society, where it now houses the Guy C. Woodward Museum—the source of most of the images in this book.

Another early investor in the community was Augustus Barnett, who homesteaded acreage between the San Vicente on the south and Santa María land grants in 1880. Barnett constructed a large adobe hacienda in 1885; a landmark that stood until its inadvertent demolition in the 1990s. The old Barnett barn has been moved and is now within the Woodward Museum grounds. Barnett and others are credited with starting the once-important honeybee industry in San Diego County.

Milton Santee, the namesake of Santee, California, was an energetic speculator and promoter. Santee led the charge to make the Santa María Valley a thriving mosaic of ranches and farms with a first-class town served by piped-in water and, in his flights of fancy, train service from San Diego. To that end, he purchased more than 3,800 acres from Etcheverry in 1886. The Santa María Land and Water Company bought the townsite of Nuevo in what was the east-central portion of the old land grant.

In hopes of better sales of the 40-acre parcels that his company carved out of the huge holding, Santee sought to change the town name to something more evocative, even romantic. In the midst of the great popularity of Helen H. Jackson's tearjerker, Santee settled on the name Ramona. Unfortunately he had to wait until 1895 to claim the Ramona name, because another Los Angeles-based promoter had already filed a claim with the postal service. When the largely paper community of Ramona to the north failed and closed its post office, Nuevo became the Ramona of today.

Santee and other backers never realized their dream of rail service to the Santa María Valley. The grades were too steep and commerce was too limited to justify the engineering and construction costs. The train did come as far as Foster's Station at the foot of Mussey Grade below what is now San Vicente Reservoir. From there passengers and freight were loaded onto wagons, and later motorized trucks, to make the arduous climb out of Lakeside and into Ramona. The great flood of 1916 destroyed the railroad track between Lakeside and Foster, impeding travel and transportation until better roads could be built.

While never gaining the fame or fortune of the mines in Julian, Banner, or Mesa Grande, Ramona has a long history of mines and gems. Gold was mined in the San Vicente Valley until the early 1930s, and copper was pulled from the earth on the old Daley/Barona Mine south of Ramona. According to local legend, Grandma McIntosh found the first tourmaline in Hatfield Creek while chasing stray cows. Tourmaline, morganite, garnet, and kunzite were all semiprecious stones that have been found and mined in the area. Over the years, many an amateur miner has gone into the hills with a sluice box or pan seeking the riches that legend states lie there.

Throughout the county, the 1890s followed the 1880s with drought, economic depression, and a land speculation crash. Besides the railroad never snaking its way into the valley, a planned University of Southern California seminary never materialized, and many of the once prized 40-acre parcels sat empty. Undaunted, Santee built the Ramona Hotel, later the Kenilworth Hotel, and the community grew. Justice came in the form of the Nuevo Township Court, later renamed the Ramona Court, with real estate broker and dairyman W.E. Woodward serving as constable from 1901 to 1907. James F. Kelly acted as Ramona's longest serving judge from 1906 to 1949.

Augustus Barnett sponsored and funded the Ramona Town Hall, an enduring landmark on Main Street. He retained San Diego's most prominent architect of the time, Will Sterling Hebbard, to design the building. The stately building is constructed of adobe blocks with a pressed brick veneer. The date of 1894 is prominently displayed above the sweeping, arched entrance.

With a population of about 116 families in the valley in 1900, Ramona was on its way to becoming a true community. The *Ramona Sentinel* reported the news, including the town's support of Prohibition. Years before Prohibition, Ramona was a "dry town"—not that a drink or glass of wine didn't find their way into the hands of citizens.

Recreation and other amenities thrived in spite of the alcohol ban. The summer of 1904 saw the beginning of the Ramona Tent Village, where denizens of the cities and deserts escaped the heat in those non–air conditioned days. Thomas P. Converse set up the village, modeled on the wildly successful Coronado tent village, in Goose Valley. The Ramona Woman's Club began in 1912 with the name of Thimble Club. With land donated by Frank Creelman, the well-known town blacksmith, a permanent building was constructed based on plans drawn by Emmor Brooke Weaver, a prominent San Diego architect. His fee was a whopping $60.

As the 1920s rolled along, dirt streets, including Main Street, were gradually paved, electricity came to many homes, a formal district was established, and the various schools that dotted the landscape were unified into a single system. The first true schoolhouse for Ramona (Nuevo) was erected in 1881 on the south side of the Julian Highway near Magnolia on rocky terrain, thus the name Rock School. When the Rock School burned down in 1890, it was replaced by another structure on Stokes's land east of Magnolia Avenue on Schoolhouse Road. A series of schools were built for the growing student population, including one called Spring Hill Grammar School in 1886, another on the Rotanzi ranch in 1897, and a substantial redbrick school that became the Ramona Grammar School in 1888. Further to the west, the Earl School was constructed

in 1896 and now survives as a residence on Mussey Grade Road near Highway 67. The Ramona Town Hall served for Ramona's first high school classes in 1894. It would not be until 1912 that its first permanent high school was built. Affectionately known as the "Old Cement Building," it was razed in 1954.

Civic pride and the quest for improvement took many forms in Ramona. Over time, the Ramona Improvement Club became the Ramona Chamber of Commerce and coined the phrase the "Heart of San Diego County." Amy Strong built a remarkable castle on the old Woodson ranch west of town, and with its completion in 1921 visitors came from hundreds of miles away to see the architectural splendor. A.C. Bisher received a state franchise to carry freight directly from Ramona to San Diego in 1922, the Ramona State Bank was solvent and paying high interest rates on the eve of the Great Depression, and water service finally came to the community, replacing wells and an inadequate flume from Hatfield Creek. Much of the credit for the new system went to J.C. Bargar, who became known as the father of Ramona's community water. Two dams greatly expanded the water system: Sutherland, begun in 1928 and finally finished in 1952, and Lake Ramona Dam, established in 1983.

From 1930 and into the 1950s, Ramona held the title of "Turkey Capital of the World." The temperate climate and inexpensive land allowed for a long laying season and huge flocks. Birds were raised for both eggs and meat with the "Ramona Broad-breasted Mountain Brand" greatly acclaimed. The cost of land, water, feed, environmental regulations, and changes in eating habits doomed the turkey business, but chicken egg production is still important in Ramona. Avocadoes were king in the 1970s and 1980s, but high water costs and Mexican imports have greatly reduced their acreage. Harkening back to the past, wine grapes are being grown in record numbers, and wineries are becoming a mainstay of the economy.

With the growth of the community, fire protection became a major issue. For decades, volunteer fire units served as the first line of defense. Initially trucks, hoses, tanks, ladders, and shovels were all donated; the first permanent fire station was not built until 1952.

Ramona's airport has been a major feature on the land and served a variety of functions. During the Second World War, the US Navy built a landing strip just west of downtown. During its short use, Navy pilots practiced bombing runs by dropping low impact explosives on whitewashed rocks configured in the shape of battleships. Remnants of these "ships" still exist near the airport. When the Navy closed the airfield, some ranchers were able to salvage scrap sheet metal, and these were incorporated into cattle shoots.

Two war veterans, Gordon Kunkle and Glen Zintz, reopened the airstrip with the County of San Diego, leasing the land from 1947 to 1957, when it was purchased outright. In the 1950s, a taxi strip became one of the first drag strips in America, and some say it was the birthplace of the National Hot Rod Association. Currently one of the important functions of the Ramona Airport is as a base for firefighting planes and for refueling.

Today, with a population of more than 40,000 people, Ramona is a mix of the past and the future, the rural and urban, the rodeo and the boutique winery. The sense of community and links with the past can be found on Main Street and in the rolling hills.

One

THE FIRST PEOPLE

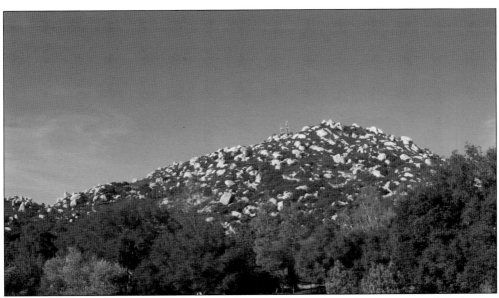

Mt. Woodson forms a western landmark for Ramona. Known to the 'Iipay as Ewiiy Hellyaa ("moon rocks"), to early settlers as Stony Mountain, and then as Mt. Woodson, this prominent peak holds sacred value to the 'Iipay people. It was here that mythical creature Toyaipa stomped the earth on his way from the deserts to the coast, leaving the dent on the left that can still be seen. (RLC.)

The village of Pa'mu on the broad Santa María plain was the winter settlement of the people of Tekemuk, or Mesa Grande. The grinding mortars in the foreground are mute testimony to years of seasonal use. In 1778, Spanish soldiers from the presidio in San Diego, fearing an insurrection, attacked the village. Homes were burned, their occupants shot down as they fled, and ears were cut off to take back to the commandant at the fort. (RLC.)

Within the broad Santa María Valley, the world of the 'Iipay contained sweet, bubbling springs. This spring at the village of Pa'mu was known for its ability to affect the gender of a baby for pregnant women. According to Isidto Nejo, the woman was required to swirl a stick with a small amount of her menstrual flow in the spring and sing an ancient chant. One spring was for males and one for females. (RLC.)

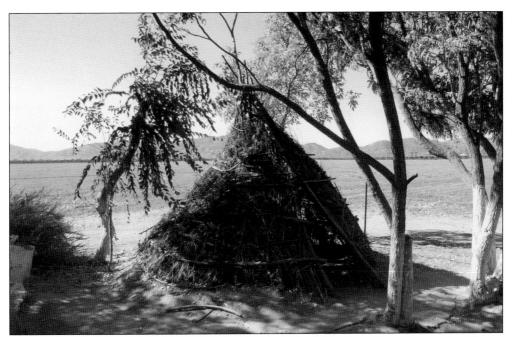

Using willow branches as a superstructure and willow and tules (bulrush) for covering, the 'Iipay of the area constructed their homes, sweat lodges, and ceremonial structures. Some of their houses, called *wa* or *wah*, were domed, while others, such as this one, were more conical. In temperate Ramona weather, most cooking and living was done outside with the wah used for sleeping and protection from the elements. (RLC.)

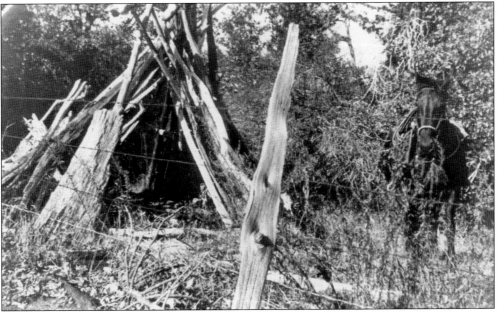

While traditional 'Iipay homes were made of willow and most often domed, this mountain wah was constructed of pine staves. Located in Lost Valley on the old Bergman property, these temporary sleeping quarters would have been used during pine nut–gathering season in the late fall. (GWM.)

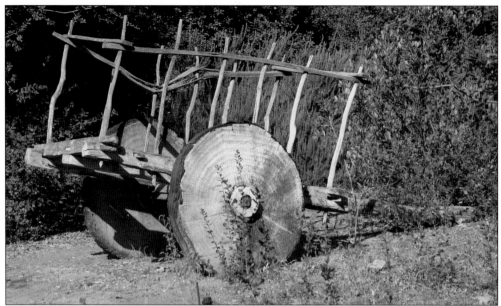

When the Spanish came into Santa María Valley in the late 1700s, they used *carretas* (small wagons or carts) such as this one to haul supplies and equipment. The old Spanish and Mexican trails that wound through the valley from Santa Ysabel to San Diego, and from what would become Ramona down the steep slopes to San Pasqual Valley, followed ancient 'Iipay trails and paths. (RLC.)

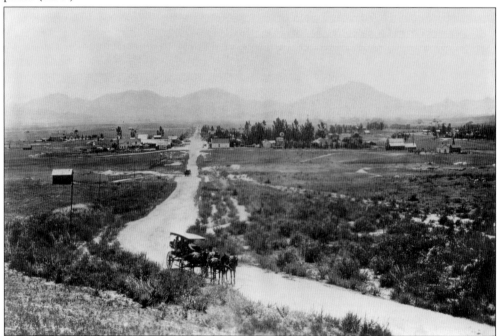

In this early view of Ramona looking southwest, the roads and trails in and out of town are not much more than widened 'Iipay trails. Reportedly 'Iipay helped to clear brush and maintain the early roads. Typically these pioneer trails followed land contours and did not have the benefit of grading or cutting. Mt. Woodson is faintly visible to the top left. (SDHC.)

14

Reamijo "Ray" LaChusa of Mesa Grande was known as a tracker, as an excellent hunter, and an accomplished dancer of both 'Iipay and non-Indian dances. The eldest son of Juan Diego LaChusa, Ray died in 1978 at the age of 83, having seen many changes to the lives of his people. (GWM.)

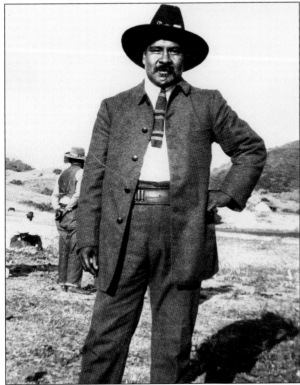

Leo Lugo rose to a position of power and authority in the Mesa Grande tribe as 'Iipay on the reservation developed strategies to cope with the federal government and to resist non-Indian squatters, who coveted the well-watered and sheltered tribal homelands. Constable Lugo held both cultural and administrative power. Lugo was reportedly a physically strong man, and at this juncture in 1913 hoped that the government would honor 'Iipay land rights.

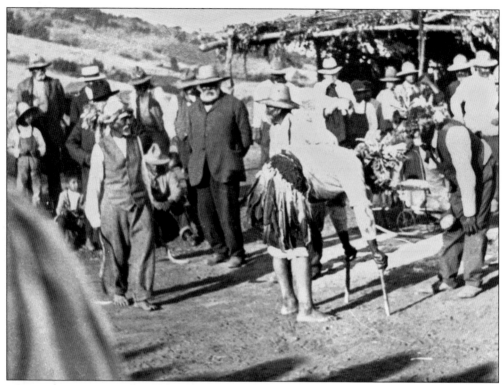

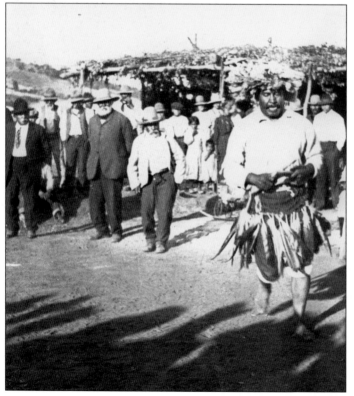

Dancing within 'Iipay culture served many purposes: to honor the sacred eagle, for celebrations, to respect the Creator, and to seek a continual rebirth of the earth and the plants. In these two images, the lead dancers are beginning an eagle dance. The bent-over dancer with the sticks in the photograph above is being watched by Cinon Metehuir "Duro," one of the most venerated 'Iipay dancers, singers, and holy men. In the photograph at left, the unidentified dancer has moved away, and a good view is provided of his owl feather headdress and feather sash.

When Lake Sutherland was built, it flooded not only a pioneer ranch but also a large 'Iipay village. Archaeologists estimate that the village was occupied from more than 2,000 years ago to as late as the 1850s. This submerged settlement is associated with the people of Mesa Grande (Tekemuk, or "sheltered place," in the 'Iipay language). (RLC.)

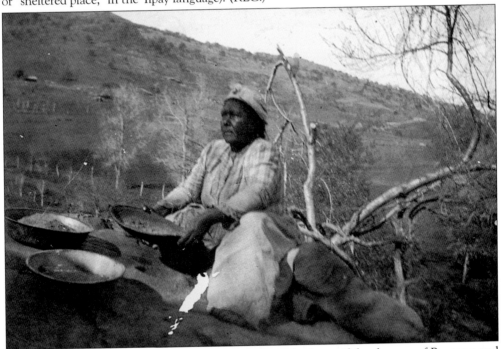

'Iipay women are masters of processing acorns from the bountiful oak trees of Ramona and Mesa Grande. Captured in this c. 1900 image, a woman is winnowing the chaff of the acorn in a traditional fiber basket. When fully separated, she will mill the nuts on a metate and place the finely milled acorns in a basket, skin, or sand basin to leach out the tannic acids. The final product might be bread or porridge.

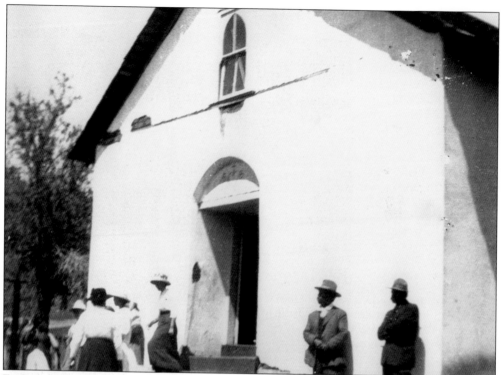

Even though the Mesa Grande Reservation is several miles northeast of Ramona, it has been tied to the community for hundreds of years. In this photograph, 'Iipay worshippers are seen in front of Saint Dominick's Church on the reservation. Mesa Grande people have always lived separate from the people of nearby Santa Ysabel. The woman with her back to the camera is Petra LaChusa Cota. Men from Mesa Grande regularly worked for Ramona ranchers and farmers from 1870 to 1930.

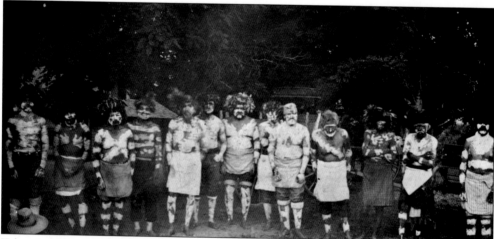

Taken in 1893 or 1894, this rare photograph shows a group of important dancers at Mesa Grande preparing to do what has been called the fire dance. They have painted their bodies with white clay, probably sourced from a special clay deposit near Matahuay. Dappling, bands, and hand designs adorn these men. The fire dance involved skirting hot embers and jumping over a bark fire, but it was meant more as a ceremony than to exhibit bravado.

Fiestas are woven into the fabric of 'Iipay society and have been since a mythical spirit ordained that tribes should share foods, play *peon*, and dance. Peon is a game of chance played with two pieces of bone or wood, one black and one white. The opposing player tries to guess which hand holds the white or black piece. Over time, the fiestas became a source of income for some tribes, who invited non-Indians to share in their bounty. Mesa Grande typically had their fiesta in November. The men are unloading supplies in preparation for this c. 1900 fiesta. Note that fiesta time brought out the good Sunday clothes.

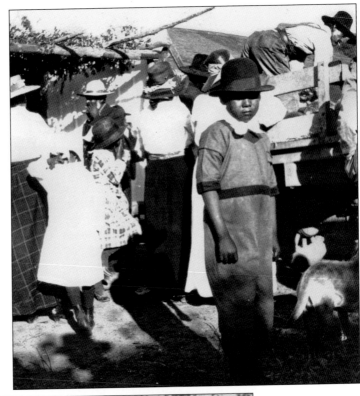

In what is clearly a staged photograph, these two Mesa Grande youths are posed as hunters in the wild. Not only do they look less than enthusiastic, the leather chaps are more suited to riding than hunting. In 1900, when this photograph was taken, hunting for game was still a way to put food on the table at the reservation.

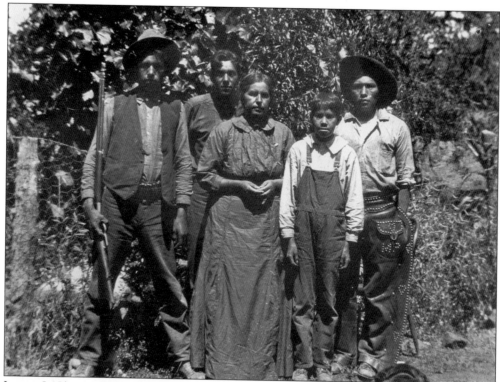

Lenora LaChusa, of Mesa Grande, was a strong matriarch who worked hard to ensure that her six boys, four of whom are pictured here, learned a trade, attended at least some school, and grew up respectful of the past. Several of the boys worked as vaqueros on nearby ranches, sheared sheep, and worked in the adjacent mines. Today the extended LaChusa family is an integral part of Mesa Grande life and politics.

Anthropologists of today are fortunate that men like Isidro Nejo left an enduring record of the 'Iipay past. Born in Julian in the 1850s, Nejo was raised in San Pasqual Valley and lived as an adult at Mesa Grande, making many trips to see relatives in Pamo Valley. In this photograph taken by famed linguist J.P. Harrington in 1925, Nejo has just related the places, names, and myths of Ramona and the region. (RLC.)

This undated photograph, taken at Mesa Grande, shows Juan Diego LaChusa, born in 1861, flanked by his two sons. The LaChusa family is known to be one of the oldest clans in the region, and many family members were keepers of traditional knowledge. A grandson of Juan Diego, Clifford LaChusa was active in politics on the reservation in the 1970s and 1980s.

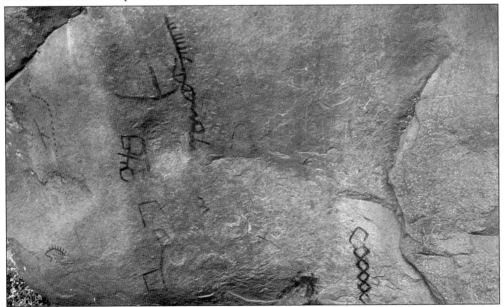

Similar in style to the pictograph shown earlier, this painted rock face is near Santa Theresa Valley on an east-facing boulder. The abstract lines and circles may be no more than a few hundred years old, or they may be more than 1,000 years old—archaeologists are uncertain as to their age. This particular style is common from the area into the eastern deserts.

Monkey Hill is an important landform and landmark to travelers. Before Henshaw Dam was built in 1923, and before the area was a ranch, the domed boulder-strewn hill was the center of an important 'Iipay village. Known as Tawi, this village had ties to San Felipe in the desert and Santa Ysabel in the southern valley. The eastern side of the hill is known as 'Eha Chepulpul, meaning "something beds here." (RLC.)

In this photograph from the early 1900s, these Mesa Grande 'Iipay are gathered in front of a traditional sweat lodge. While adopting many of the material items of American culture, the local tribes also continued to practice traditional rituals, including sweats and purification. (SDMM.)

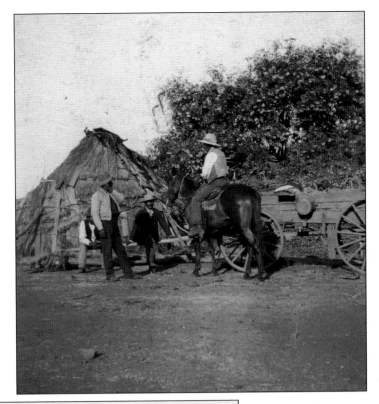

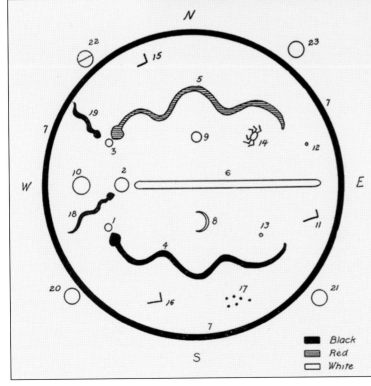

In this image of an original 'Iipay sand painting published in 1910, the universe is symbolically depicted. The six dots (17) represent the beautiful seven sisters known as the Pleiades. They are being chased across the heavens by 'emu (16), the big horn sheep who loves them. This constellation is called Orion. (RLC.)

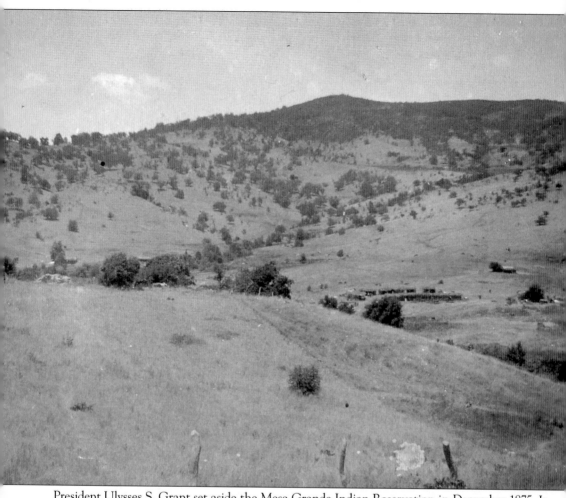

President Ulysses S. Grant set aside the Mesa Grande Indian Reservation in December 1875. It was one of the first federal reservations in San Diego County and has grown over the years. In this view, it is clear why the traditional name of the land is Tekemuk. (SDMM.)

Two

RELIGION, EDUCATION, AND COMMUNITY

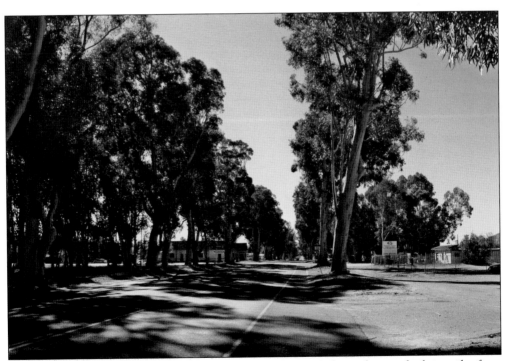

At its greatest extent, the historic Main Street Eucalyptus Colonnade stretched six miles from the western edge of town into the heart of the community. Originally planted in 1909, added to in 1931, and in-filled with new trees over the decades, this double row of towering trees is considered by many to be a cultural landscape that frames a scenic route and acts as a historic landmark as well. (RLC.)

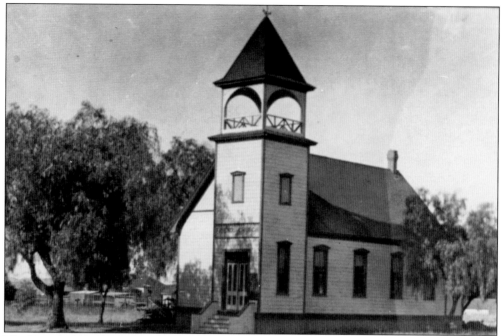

The Friends Church was the first religious congregation established in Ramona, and in 1889 it heard sermons from Rebecca Naylor, a noted evangelist. The Friends erected a building on this site on the north side of Main Street in 1893. William E. Mills served as the church's first pastor. The church accepted and preached to various denominations, and in 1922 the current sanctuary was constructed.

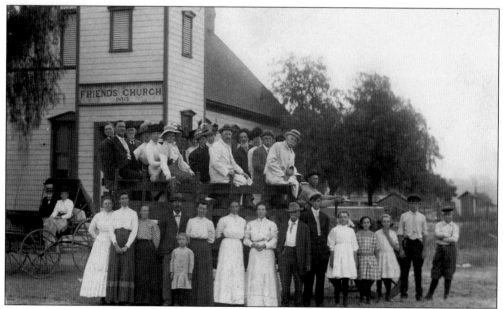

In this early 1900s image, the congregation of the Friend's Church is captured in front of their church on Main Street. Many of the parishioners of the church were associated with a settlement in Los Amigos (Goose) Valley. The vehicle holding some of the folks appears to be an early motor truck with hard rubber tires.

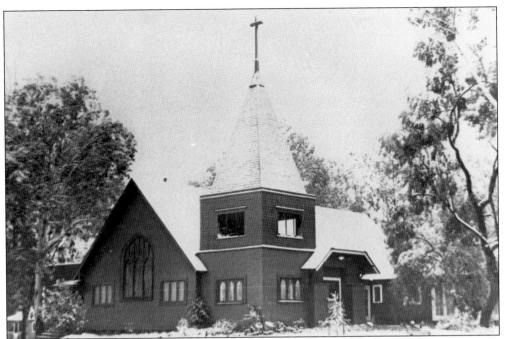

With roots extending back to 1898, the First Congregational Church is the only continuously operating denomination in Ramona. From its beginning with services held in the old Earl School on Mussey Grade Road, the church met in several locations around town, including the Friends Church, before erecting this redwood edifice with Gothic-styled windows in 1907. In this 1949 photograph, a rare snowfall in Ramona blankets the building.

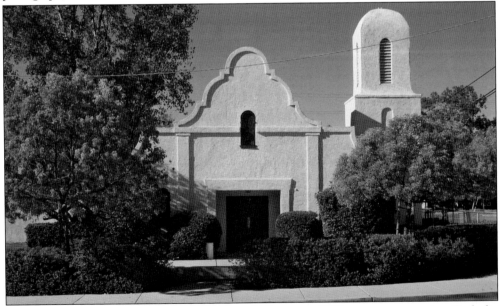

This Mission Revival church was erected on E Street in 1950 to serve a growing Catholic community in Ramona. Prior to 1950 and the establishment of this first Catholic church in the area, parishioners worshipped at the Woman's Club on Sundays and at Mission Santa Ysabel on Wednesdays. A much larger Catholic church was built across the street in 1989. (RLC.)

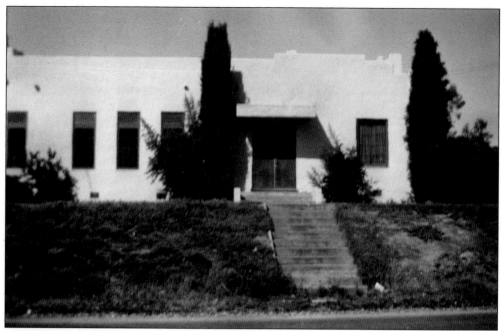

Built in 1938 on land purchased from the Ramona Irrigation District, the Seventh Day Adventist Church is an excellent example of the moderne style of rectangular stucco institutional buildings common in the 1930s.

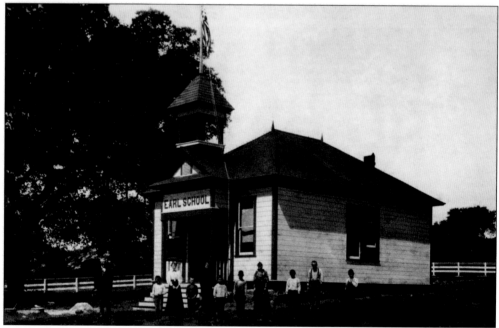

Education is one of the mainstays of community life, and construction of the Earl School in 1886 on land donated by Bernard Etcheverry was a major step. There is some dispute as to whether this c. 1896 photograph depicts the original school, which was moved to Mussey Grade, or a new building at that same location. Even the name is somewhat uncertain, with Earl or Earle both given as the name of Etcheverry's wife's maiden name.

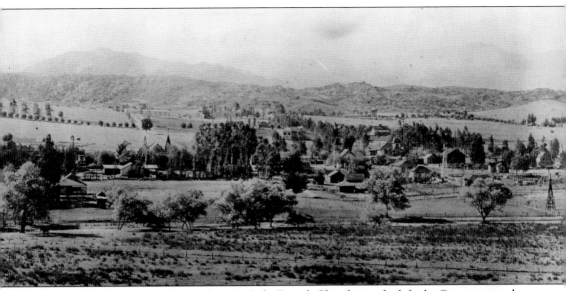

In this view from the south to the north in 1887, the Friends Church is to the left, the Congregational Church is right of center, the high school is in the center, and the new Ramona School at Ninth and D Streets is to the back right of the Congregational Church. Windmills and elevated water tanks still provide the bulk of the water supply, and the community quietly awaits the building boom of the 1890s.

Today the Earl School is a well-maintained residence that is largely unaltered from its appearance in 1897. A fireplace and chimney were added to the north side, and the ornate bell tower has been removed. At its location near the entrance to Mussey Grade Road from Highway 67, the traveler practically drives back in time, heading down the old road south towards San Vicente Reservoir.

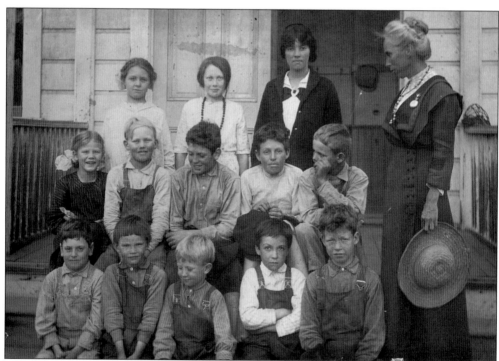

In this classic school photograph taken in 1915, the largely male class exemplifies the overall-clad farm boys of the time. The teacher, with straw hat in hand, seems to be mildly disapproving of her charges. One almost suspects that there is a frog hidden somewhere, waiting for its moment of surprise. One-room schools such as this comprised of multiple grades were the rule at the time.

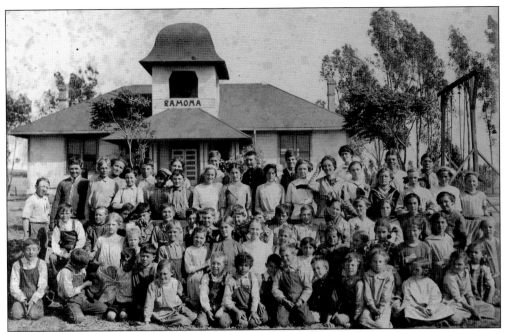

The students of Ramona School pose for the annual all-school photograph. The student body would seem to be mixture of farm boys and girls in their simple overalls and smocks. Some of the kids appear to be citified with jackets, ties, and some frilly dresses for the girls. This blending of the country and the city typified Ramona life for many decades.

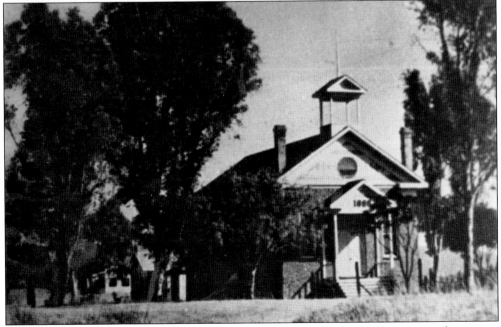

The Ramona School, built in 1888, is of a similar style to the Earl School constructed two years before, but it was much more substantial being constructed of brick. The land for the school was donated by the Santa María Land and Water Company, no doubt to encourage settlement on its 40-acre parcels of land through the valley. The school was heralded as a great improvement.

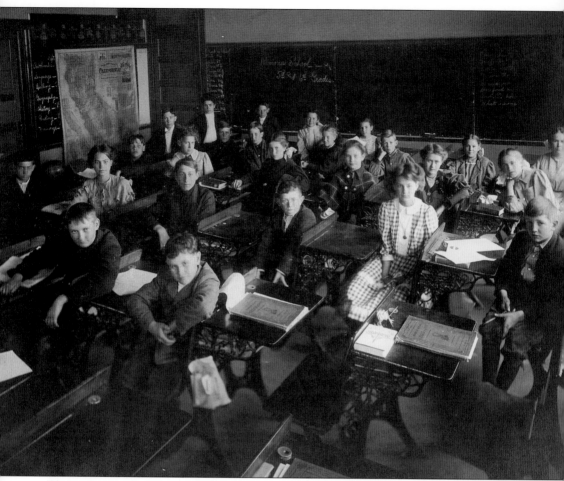

This attentive class at the old Ramona School consisted of fifth and sixth graders. It would appear that the day's study included California, and the books on the desks are geography texts. Apparently protecting students' delicate egos was not practiced as it is now; their rank in the class is printed on the chalkboard. With the group numbering less than 25, this class would be the envy of teachers today.

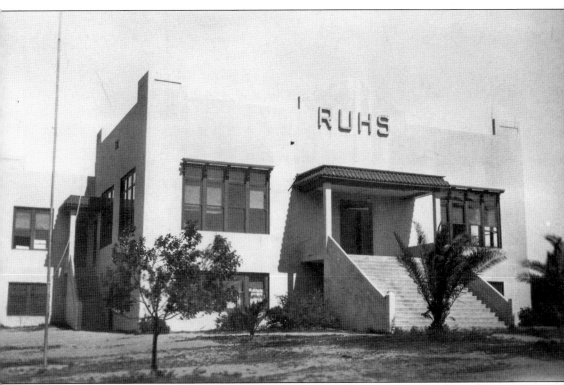

In the midst of the Great Depression, Ramona finally received a new high school. The $60,000 funding for construction came from local school bonds and the federal Public Works Administration. Built in 1936, the educational facility was designed by noted architect William P. Lodge and touted as earthquake proof. Keeping with the style of the times, the building is moderne, reflecting the art deco period.

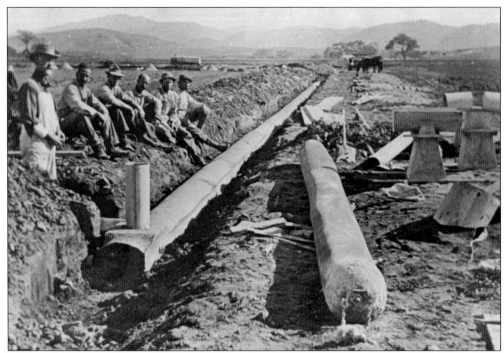

In 1915, considerable effort was put into bringing large-scale irrigation lines into the valley. Here men are laying concrete pipes formed around the elongated inflatable tube of rubber to the right. When the cement had set, the tube was deflated and the pipes rolled into place and then joined with the other segments. This portion was on the Wilfred Woodward property at the northwest end of Fifth Street.

Sutherland Dam was begun in 1927, but structural problems with the foundation resulted in it being shifted, and given the Great Depression and World War II, the dam was not completed until 1954. Few boaters and fishermen realize that beneath the more than 100 feet of water sits the old Kieth ranch site and an 'Iipay settlement. (RLC.)

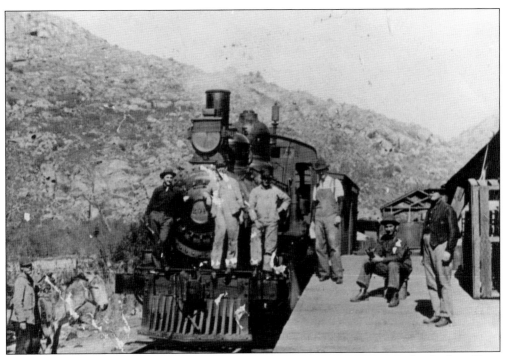

The much-desired railroad made it only as far as Foster's Station—a terminus for the line. From Foster's passengers and freight were shifted to wagons, and later automobiles for the rest of the trip to Ramona. In this late-1890s photograph, Engine 201 looks ready to make the run back to Lakeside and then to San Diego. The tracks from Lakeside were destroyed in the 1916 flood and never rebuilt.

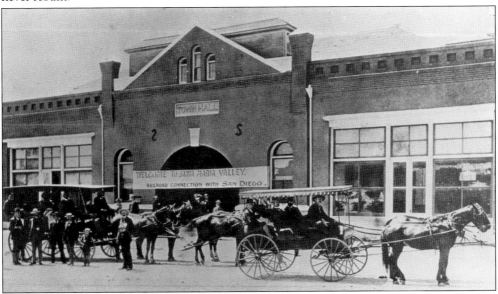

In spite of the best efforts of local backers and politicians, the train never came to Ramona. The hopes of delegations such as this one lined up in 1904 were finally dashed when the 1916 "Hatfield Flood" wiped out the tracks to Foster's Station below Mussey Grade—there would not be "A Railroad Connection to San Diego" in spite of what the banner on town hall proclaims.

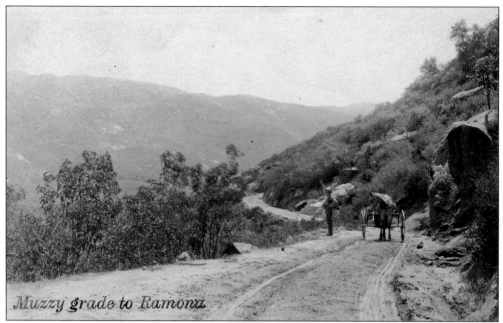

Muzzy grade to Ramona

In this c. 1890 photograph of Mussey Grade, the buggy driver is experiencing the joys of a recently graded dirt road surface. More often, the road was rutted, muddy in rain, and sometimes strewn with boulders that tumbled from the steep cliffs above. Prior to construction of San Vicente Lake in 1943, this winding, narrow road brought travelers from Foster's Stage Station near Lakeside to Ramona.

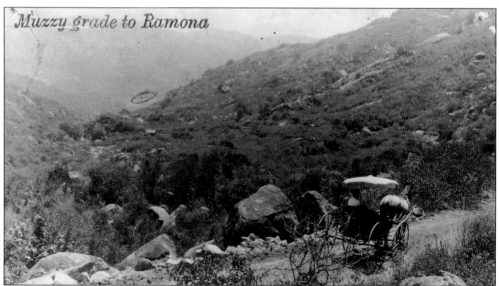

Muzzy grade to Ramona

If this man in his buggy, probably Mark Kearny, could return to the same spot on Mussey Grade Road today, he might be amazed. The road is paved now, but it dead-ends into San Vicente Reservoir, which he would be able to see over his left shoulder in the canyon at the top left of the photograph. But in many ways, the view is unchanged.

Mussey Grade as it runs south from Highway 67 to its terminus above San Vicente Reservoir was once a major travel corridor linking San Diego and Julian via Ramona. Named after Albert Mussey, who owned Mussey's Pleasant Grove, today the road is listed as a County Historical Place of Interest, and with its tunnel-like arbor of oaks it is a symbol of two-lane rural roads. (RLC.)

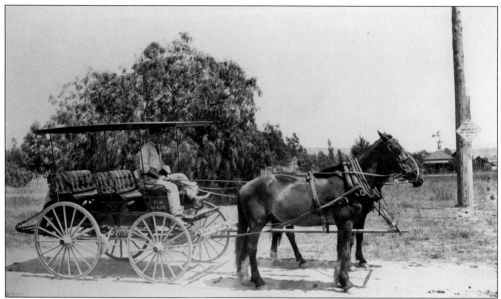

US mail came to Ramona in many ways. Before gasoline powered trucks, the mail would be carried in wagons or buckboards. This two-horse rig is on Main Street heading west. The sign on the post reads, "Santa Ysabel, Julian, Warner's Hot Springs," with an arrow pointing to the left (east).

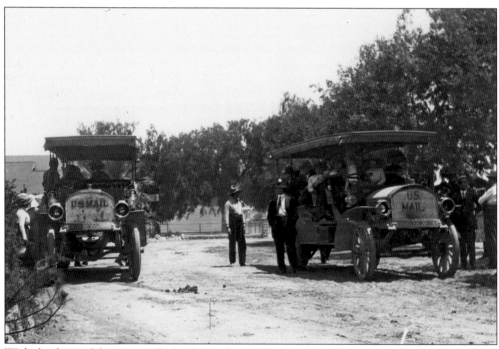

With the dawn of the motor vehicle, the mail entered a new era in delivery service. In this undated photograph, local citizens get a chance to see and ride in the noisy contraptions—fringe top optional. Even with the new trucks that rode on hard rubber tires, some roads were still better served by horse and mule.

The Mason's Building at Ninth and Main Streets has served as the meeting hall for the Santa María Masonic Lodge No. 580 F&AM since it was built in 1926. Prior to that, the Masons met in the town hall like many civic groups and service clubs. Albert C. Bisher and Adrian B. Elliot were key figures in the Masons' lodge and in ensuring that this building was constructed. (RLC.)

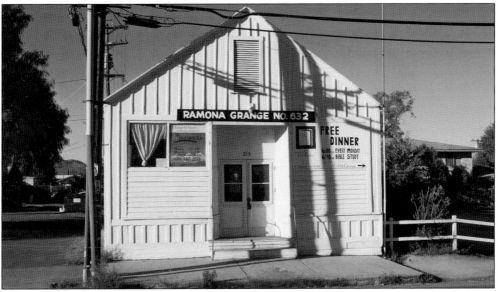

The Ramona Grange No. 632 was founded in 1914 and included many of the prominent farmers in the community. Serving as a social and political organization, the Grange occupied this front-gabled building at Seventh and B Streets beginning in 1924, when it was moved to the site. Built in 1895, this structure was originally located immediately west of town hall on Main Street and was the old Miles Store that was replaced with a new building in 1926. (RLC.)

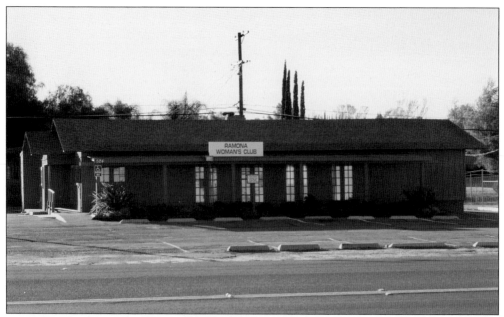

Formed as the Thimble Club in 1912, the Ramona Woman's Club has always been an active civic organization. In World War I, the club won a silver medal for rolling bandages for wounded American soldiers. This redwood building on the south side of Main Street has housed the club since its construction in 1917, having been designed by the famous architect Emmor Brooke Weaver, who also drew the plans for Amy Strong's castle. (RLC.)

Helen Stoddard lived in this gabled clapboard home on I Street that she and her husband built in 1926. A graduate at the top of her class at Wesleyan College in New York in 1871, Stoddard was the first woman to run for Congress, making her bid on the Prohibition ticket. Stoddard fit well into the temperance-minded community of Ramona, which at times voted itself a "dry" town and celebrated the Volstead Act. (RLC.)

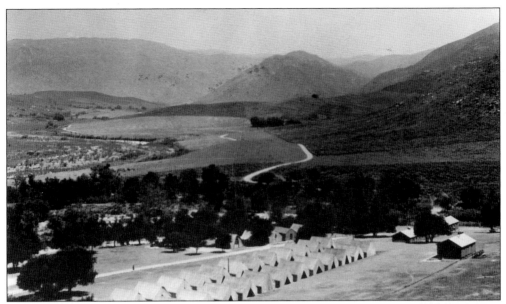

This overview of the Civilian Conservation Corps camp in Pamo Valley depicts the extensiveness of the camp. They were self contained, somewhat austere, orderly, and had a rigorous semi-military organization. While some men protested the regimentation, with the outbreak of World War II in 1941 many of the CCC workers joined or were drafted into the military services.

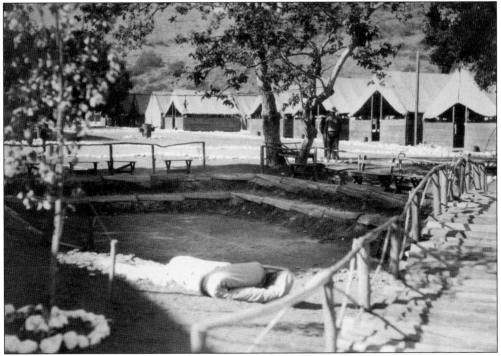

Ramona housed two Civilian Conservation Corps camps, one in Pamo Valley and the other at Mt. Woodson. In this 1933 image of the camp at Pamo, the tent housing with hard sides and other facilities are depicted, as well as the sunken amphitheater where classes were taught. In addition to earning a wage, the men were taught skills such as masonry, carpentry, and metalworking.

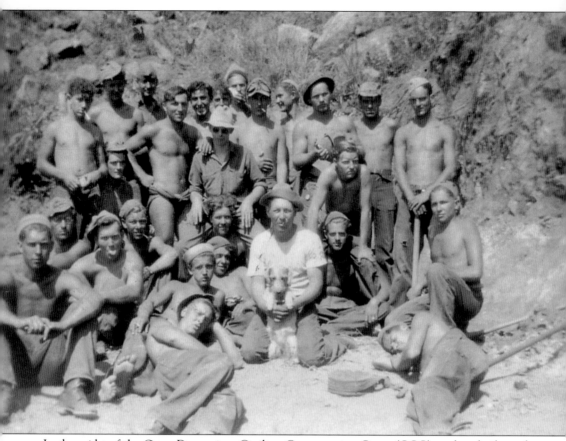

In the midst of the Great Depression, Civilian Conservation Corps (CCC) workers built roads, flood-control systems, parks, and public works. The CCC operated from 1932 to 1938, during which these buffed young men stayed at the Pamo Valley CCC Camp. Among this group are local men and workers brought in from throughout California. The man in the white T-shirt is Gene Warnock. Some of these men may have worked on the stone culverts in Collier Park.

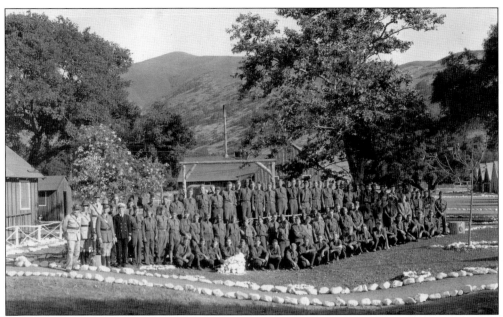

Looking a little more regimented in this group photograph than with their shirts off, the men at the Civilian Conservation Corps Camp at Pamo strike a collective pose. The camp in Pamo Valley was ideally situated because it was self sustained, had well water, and was sufficiently isolated from the town to reduce mischief. By all accounts, most workers enjoyed the meals, the pay, and even the outdoor work.

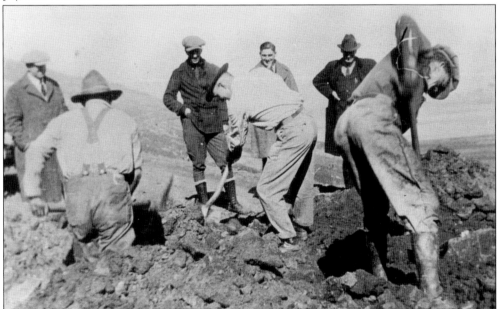

In 1923, the new Henshaw Dam was largely completed. It became the largest reservoir in terms of maximum capacity, although that capacity is rarely, if ever, met. Located between Santa Ysabel and Warner's, it is operated by the Vista Irrigation District. Pictured to the right is Frank Baldwin, son of Ramona pioneers Louis and Effa (Pepper) Baldwin. The lake basin had many names for the 'Iipay; one meant, "white swan."

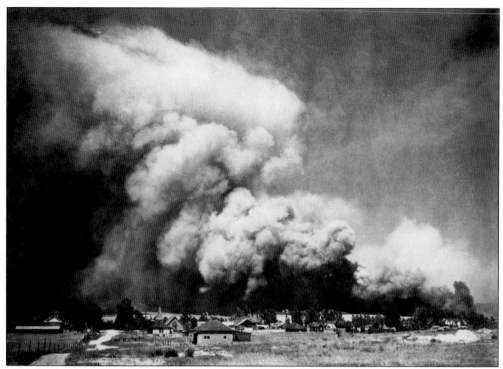

The wildfire of 1913 burned north of town and luckily avoided the community. This view is from the south looking across the edge of town. While such wildfires did sometimes burn homes and property, the area was still sparsely populated, and farms and ranches cleared the areas around their structures.

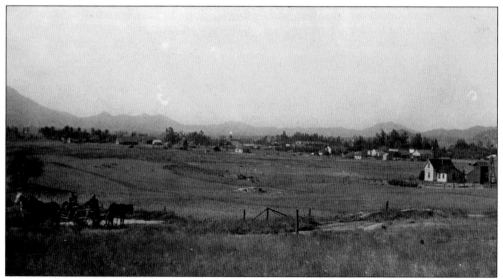

In 1910, Ramona was on the verge of commercial growth in its Main Street center. Looking west from approximately Third and H Streets, the Dan Janeway homestead can be seen to the right. Behind the Janeway house, and to the left, is Main Street. In the right foreground, two men seated in their wagons appear to be having a leisurely conversation.

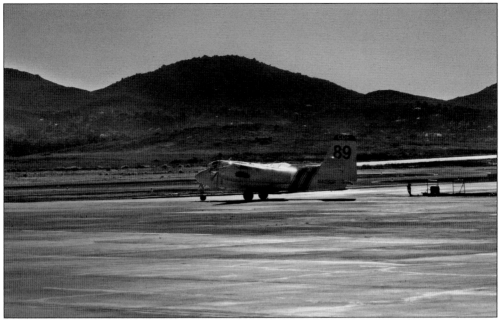

In both the Cedar Fire of 2003 and the Witch Creek Fire of 2007, CDF spotter planes and Grumman air tankers, such as this one, were instrumental in battling those devastating wildfires. The S2T is capable of holding 1,200 gallons of fire retardant, and many of the pilots and crew members are citizens of Ramona. (RLC.)

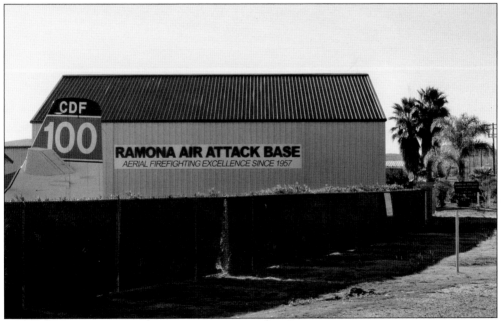

Since 1957, the California Division of Forestry (CDF) has operated out of the Ramona Airport. The airbase is vital in the CDF's ongoing attempts to suppress and contain small and large fires that threaten the county. Situated at an elevation generally above the fog line, the airport offers ideal conditions for landings and takeoffs. (RLC.)

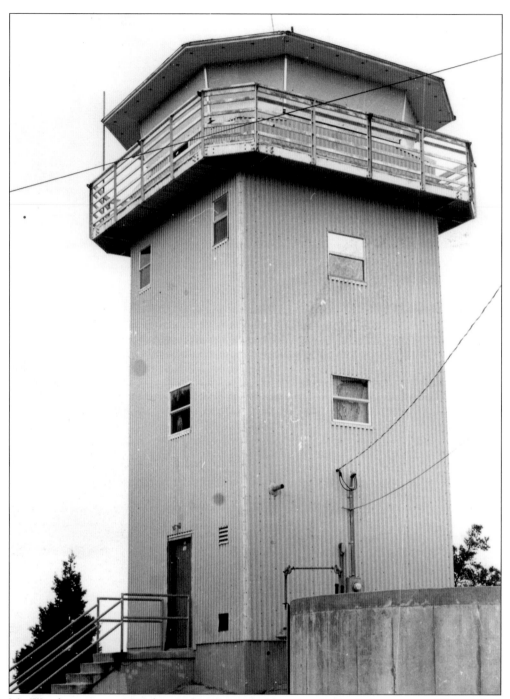

Mt. Woodson rises to 2,901 feet, making it an ideal location for fire lookout towers. The original tower on this location was built in 1936 and was replaced by a more substantial tower that burned in the 1967 wildfires. Replaced by the tower in this photograph in 1968, the second and third floors served as living quarters. This tower was dismantled in the 1980s. (GWM.)

Three

PEOPLE ARE
THE COMMUNITY

In front of the Schwaesdall Winery on Highway 78, veteran Johnny Schwaesdall erected a Vietnam Memorial in honor of the seven citizens of Ramona who died in that conflict. A War Memorial Gates plaque, honoring the Ramonans who gave their lives in war, can be found at Nuevo Memory Gardens. (RLC.)

In the early years of Ramona, one man, an ex-Confederate soldier and retired dentist, cut quite a swath. Doc Woodson homesteaded on land at the base of what was then known as Stony Mountain and turned his ranch site into a veritable Garden of Eden. His vegetables were renowned, his coffee strong, and wine made from his purple grapes was even stronger. Doc counted many of the early pioneers who were northern Yankees to the core as his friends.

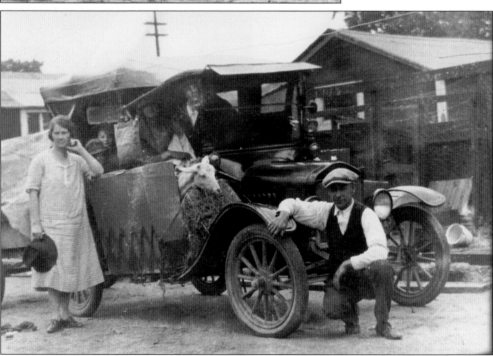

The Parks family is pictured either arriving or leaving Ramona in this 1920s image. Looking very much like the Joad family from *The Grapes of Wrath*, Hazel Parks (far left) and James W. Parks (far right) appear to have their children and their worldly belongings in this vehicle and the trailer behind it. This included livestock and the hay for feed.

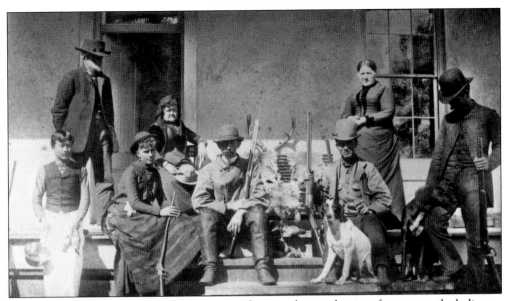

The Augustus Barnett house, and the surrounding ranch, was the site of many a potluck dinner, picnic, and hunting party. In this late-1890s photograph, Barnett and his wife are in the upper left-hand corner of the image, while the others are not identified. The cook with the pan, to the lower left, appears ready to get started on the quail and other bounty brought down by the hunters with their double-barreled shotguns.

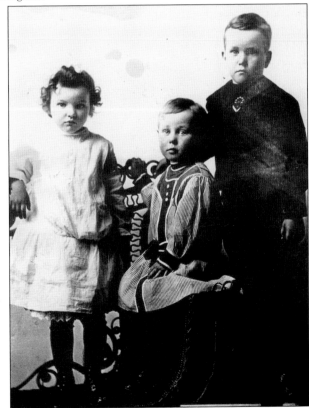

Augustus Barnett came to Ramona in 1877, and by 1885 he had built an adobe ranch house and raised a large family. Three of the Barnett children are shown in this 1890 photograph. As befitting a studio portrait, the children have on their Sunday finest and would clearly rather be outside playing.

The Louis Baldwin family came to Ramona with their children in 1908 from Texas. The family soon grew to 10, but only eight lived to full adulthood: one son was killed by snakebite and one in a stampede. In this c. 1910 image, James Baldwin and his wife, Effa, stand in the center flanked by their eight children. Three daughters, including Mamie (second from right), married into prominent pioneer families: the Dukes, McIntoshes, and Kings.

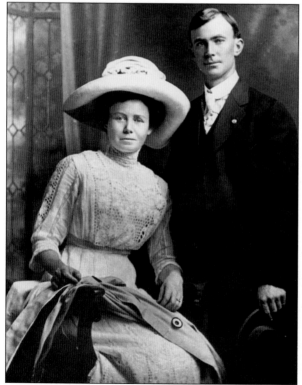

All dressed up and barely holding back a big smile, Elizabeth "Daisy" (Warnock) and Andy Pepper pose for their wedding photograph. They had two sons, Melvin and Bud, and Daisy lived a long life, dying in 1968 at the age of 86. Andy arrived in Ramona at age 18 with his parents, Benjamin and Sally, in 1903 and settled near Ballena. An older brother, Benjamin F. Pepper, owned the house in town at Elm and Cedar Streets.

Born in 1886, James Dukes helped found the Ramona Grange in 1914 and served on several civic commissions, including the cemetery board. He was the son of early pioneers William D. and Celestine Dukes, who first lived in San Vicente Valley and later in Goose Valley. James Dukes Elementary School is named after this influential and community-minded man.

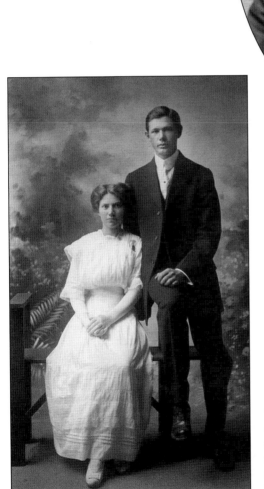

This stylish couple, James and Mamie Dukes, could not have guessed during this 1912 studio sitting that Mamie would not live more than a year. She was the daughter of James and Effa Baldwin, pictured in the Baldwin family photograph on the previous page.

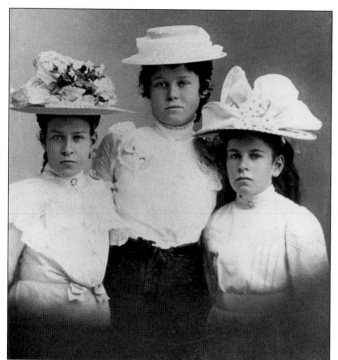

These three charmers are the Quincey girls in some Easter finery. From left to right, they are Naomi, Daisy, and Amelia. They were the granddaughters of William Billingsley and the daughters of Zaccheus Quincey and Martha Billingsley. They grew up on the old homestead on the flanks of Whale Mountain above Ballena Valley.

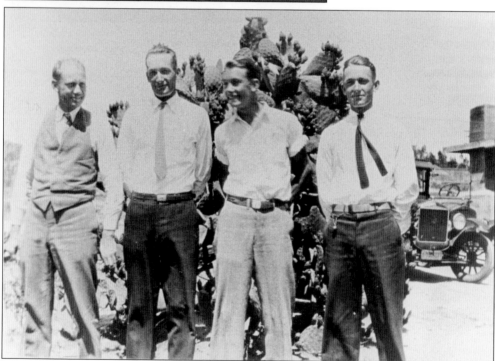

Harlan J. Woodward settled in Ramona in 1907. His sons, from left to right, are Art, Harry, Barker, and Guy. Guy worked in law enforcement in Oceanside and El Centro and was important in the development of what became the Guy B. Woodward Museum and the Ramona Pioneer Historical Society. Art is discussed elsewhere but was a noted historian and archaeologist. (KW.)

Most images of George Sawday depict him in his later years as a seasoned rancher and elder spokesman for the backcountry life. This is common for many photographs of pioneers, but it paints an incomplete picture of who there were. In this photograph, Sawday is 21 years old, and his youthful poise hardly hints at the role he will play in the history of the Ballena area with his early store and in the cattle industry.

The Angel family has strong roots in the Mesa Grande and Ramona community. James and Henrietta Angel bought the old James Gedney ranch in 1880 and raised a large family of 11 children, including Jack. Their lands abut the Mesa Grande Indian Reservation that was established by President Grant. Angel Mountain, above Mesa Grande, is named for James and Henrietta; the Angel family still ranches and lives at Mesa Grande.

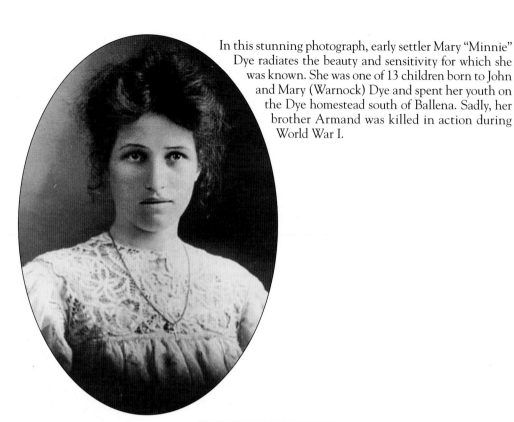

In this stunning photograph, early settler Mary "Minnie" Dye radiates the beauty and sensitivity for which she was known. She was one of 13 children born to John and Mary (Warnock) Dye and spent her youth on the Dye homestead south of Ballena. Sadly, her brother Armand was killed in action during World War I.

Sitting in this studio photograph, Amy Strong seems to portray the self-confidence and warmth that her Ramona friends and neighbors often remarked upon. Her Mt. Woodson castle was often the site of fundraisers, charity events, and elaborate Christmas parties for young and old alike.

World War I began for America in April 1917 and Arthur "Art" Woodward served his country. Woodward grew up in Ramona and led an exciting life. His adventures included his military career, trips to uncharted lands, and expeditions to archaeological ruins, including Casas Grande in Arizona. He was an archaeologist and historian who left an important body of published and unpublished manuscripts, including a seminal piece on the Battle of San Pasqual.

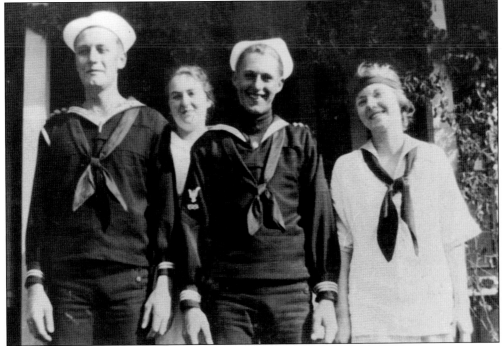

Ramona has sent its men and women into wars since 1880, and in fact several early pioneers fought in the Civil War. These proud sailors and their companions were captured on film in 1917, and with the US declaration of war in April 1917, may have been called to the European theater. Pictured from the left to right are George Sheldon, Ethel Castainin, Greg Perkins, and Inez Miles.

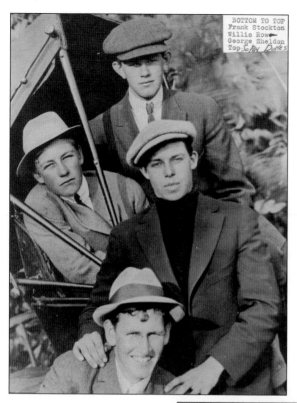

BOTTOM TO TOP
Frank Stockton
Willis Row
George Sheldon
Top John Dukes

The handsome young men in this posed studio shot look out from the past with a mix of seriousness and mirth of their age. From bottom to top, they are Frank Stockton, Willie Row, George Schiller, and John Dukes. Frank's father, James, helped construct the Congregational Church, Willie's dad played a role in planting the Main Street tree colonnade, and John Dukes was the son of William Dukes, a pioneer of Goose Valley.

The Warnock boys—Sam Jr., James, and Bob—were well known in early Ramona; they never married. Their only sister, Daisy, married Andrew Pepper. Dressed up for this portrait, it is hard to imagine that Sam Sr. was a rough-and-tumble man, fearless when it came to riding the old mail route from Fort Yuma to San Diego. Sam Jr. and his siblings grew up in Ballena Valley when it was truly still the frontier.

Ballena Valley and the name Littlepage are woven together through history, beginning in the 1870s with William Littlepage and his son Charles. As World War II raged on other shores, Charles's son Arthur appears very much from another time. Astride his horse at Ballena with rifle in hand, this image could be from 1860 instead of 1940.

When Judy Van der Veer looked out on the landscape near Ballena, she gained insights and inspirations that led to a successful literary career. Her best-selling books used the area as their backdrop. She lived in the old Littlepage house near Highway 78 and is well remembered by neighbors. "Eighty percent of the city people should not be allowed outside of the city limits," she said. "They get out in the country and try to make everything like the city."

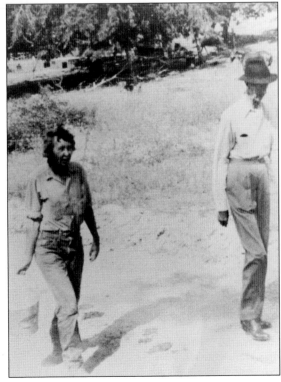

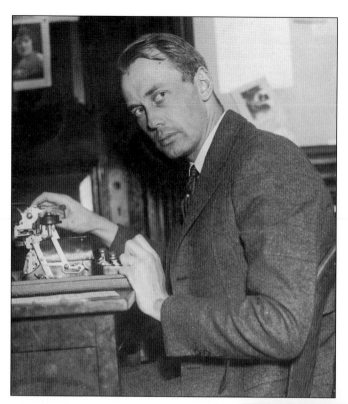

Arthur Woodward was truly a renaissance man of the 20th century. During his long life, this homegrown Ramona boy graduated from Berkeley, served in the Army, worked for both the Los Angeles County Museum and the Smithsonian, traveled with Admiral Byrd on missions with the Office of Strategic Services, wrote countless articles and books, and was a pioneer in Southwestern and California archaeology. (KW.)

George Telford was a gifted carpenter and craftsman who passed those skills on to his son Clarence, who was also an excellent football player. Telford built or assisted in the construction of many of the early homes and buildings in Ramona from around 1890 to 1920, including the Congregational Church. Clarence also built the Green/Ramona Hotel.

Hunting and fishing have always been favorite pastimes for many of Ramona's citizens. Probably the best-known hunter was Sicilian immigrant Corradino Lupo Grosse, pictured here around 1940 with a mountain lion that he bagged in the backcountry. Lupo was known to disappear for weeks in the backcountry, always returning with game or a trophy from the hunt.

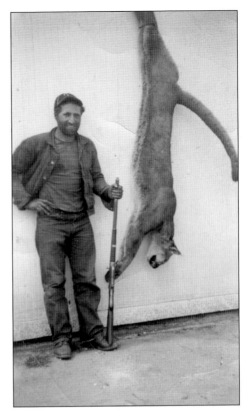

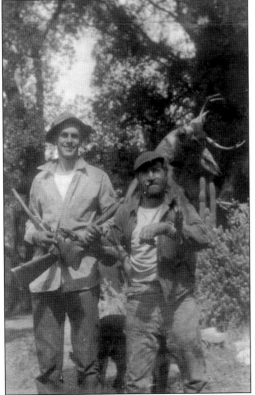

In this photograph, Dick Woodward (left) and Lupo Grosse are clearly pleased with the deer slung over Grosse's shoulder. Darrell Beck wrote that, at one time, Grosse lived in a tree house near Boochies Dam, although in his later life he settled down. He and his wife, Irene, raised children, and Grosse became the somewhat untamed grandpa to his grandchildren.

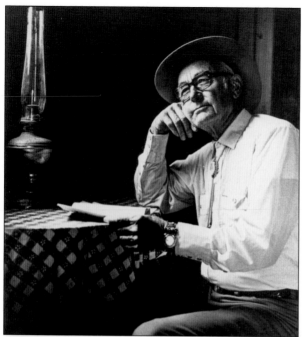

Guy Woodward appears pensive in this photograph. He had seen his little village grow into a town replete with stoplights. Woodward and his wife, Geneva, were instrumental in working with pioneer families and old-timers to preserve Ramona's past. His namesake museum, from which the bulk of the images in this book were obtained, contains a wealth of documents, books, photographs, and films stretching back more than 100 years.

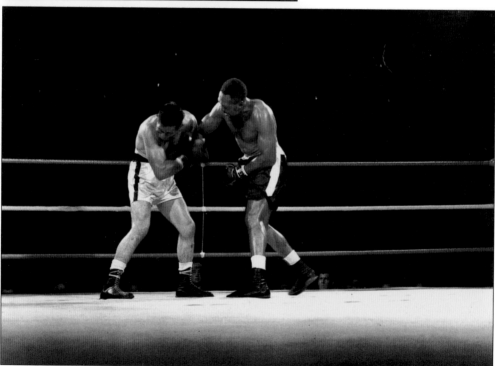

Newcomers to Ramona may be puzzled by the name on the road at the base of Mt. Woodson. Coined for Archie Moore (right), this road honors a legend in the boxing world and a true humanitarian. In his later years, Moore built a training ring dubbed the "Salt Mine" in the mountain's shadow and not only trained aspiring fighters, he worked with troubled youth through his "Any Boy Can" program. (SDHC.)

Four

RANCHES AND HOUSES MAKE A HOME

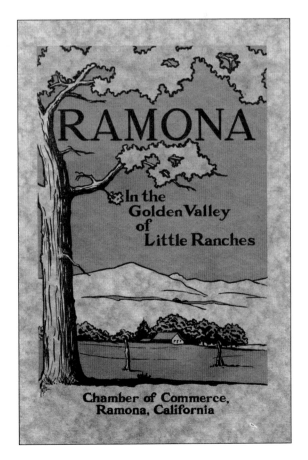

The theme of this 1923 chamber of commerce brochure is "In the Golden Valley of Little Ranches." Indeed, the various land development companies sought to entice city dwellers and those hankering for open spaces to buy a 40-acre parcel for country living, retirement, or speculation. The Great Depression wiped out many of those dreams, but they were reawakened in the 1950s, and today's sales pitch is strikingly similar.

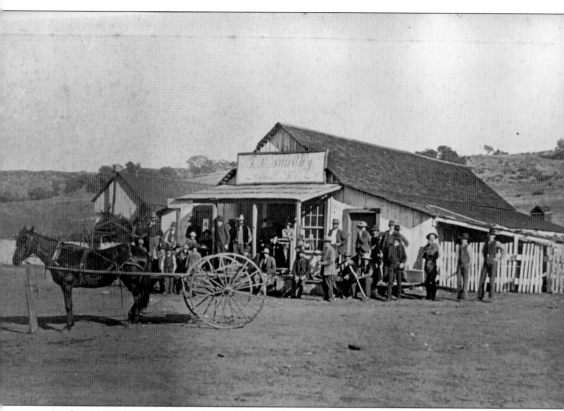

In this 1881 photograph, Frederick Richard Sawday's store had been open for less than a year. Situated on the road to Julian at Witch Creek, the store provided basic supplies, water, and as shown in this image, a place to hang out and swap tales. A portion of this old store was incorporated into his son George's home and still stands immediately south of Highway 78.

In this 1930s photograph, two women are holding what made Ramona the "Turkey Capital of the World." Throughout the 1930s and well into the 1950s, Ramona raised and sold as many as 200,000 turkeys and more than 600,000 turkey eggs a season. Ramona turkeys were shipped far and wide, including one that was enjoyed in the Truman White House.

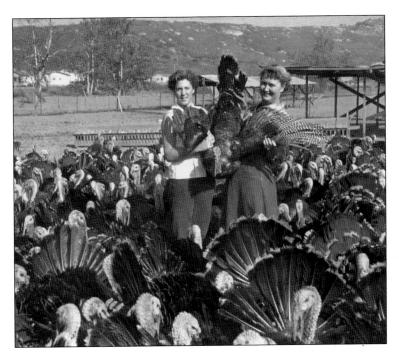

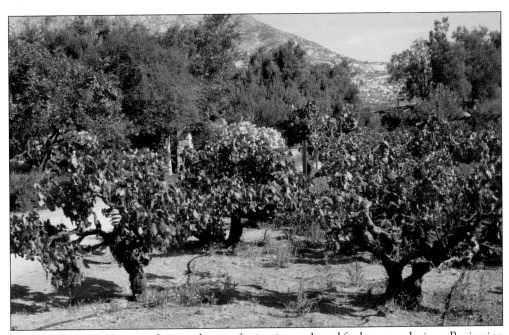

Before Prohibition, Ramona became known for its vineyards and for hearty red wines. Beginning with Verlaque and Doc Woodson and continuing into the 1920s, French and Italian immigrants planted extensive vineyards in the area. While most of the old vines have not survived, a new generation of grape growers and wine makers have sprung up. Ramona, a certified American Viticultural Area since 2006, has 19 bonded wineries and more than 57 vineyards. (RLC.)

In 1925, Goose Valley was still wide open, although Samuel Rotanzi had maintained a dairy farm here since 1890, and J.P. Converse ran his short-lived Ramona Tent City from 1903 to 1907. In the 1890s, the Friends Church purchased 500 acres here, hoping to start a colony. They named the valley Valle de Los Amigos (Valley of the Friends). Local legend has it that the name Goose Valley arose from a slurring of the word "amigos."

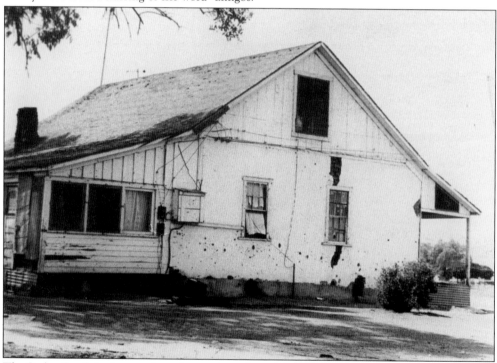

The Stokes family built several residences throughout Santa María Valley. This adobe belonged to Adolfo Stokes, son of Capt. Edward Stokes. The home was constructed in 1872–1874, making it the oldest remaining adobe in Ramona. Upon the deaths of Adolfo and his wife, Dolores Olvera, their son Aristides resided in the house until selling it in 1920, shortly before this photograph was taken. The house is just north of Highway 78 near Magnolia and has been carefully restored.

Fernbrook is one of those little communities tucked away in the hills of Ramona. Nestled comfortably just off Mussey Grade Road, the Fernbrook House is a fine example of rustic architecture with its walls of native rock, hewn wood, and large front porch. The house, built around 1930, once served as a lodge and cafe and is today a private residence. (RLC.)

Originally built in the 1870s for Mr. Williams, this small Victorian home miraculously survived the Cedar Fire that consumed most of the homes on this portion of Mussey Grade Road. Known since 1904 as the Drake house, this structure was once an unofficial mail station and store. There is also a stone milk house, or springhouse, and an old barn. The current owners, Richard Zelmer and Usha Patel, have planted and maintained a virtual cornucopia. (RLC.)

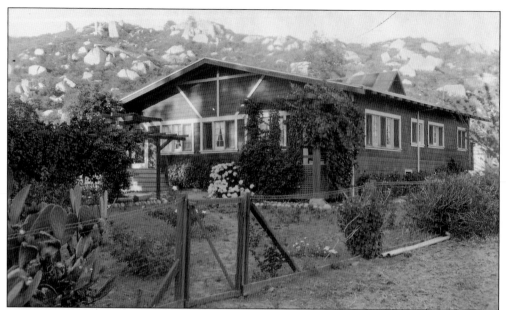

Louis J. Wilde developed the Wildwood ranch in western Ramona, replete with this cozy ranch house, in 1914. By the time this photograph was taken in 1920, Wilde had sold the ranch and became mayor of San Diego. Coincidentally, a later owner was John F. Forward, who founded the Union Title and Trust Company in 1903 and was also mayor from 1907 to 1909.

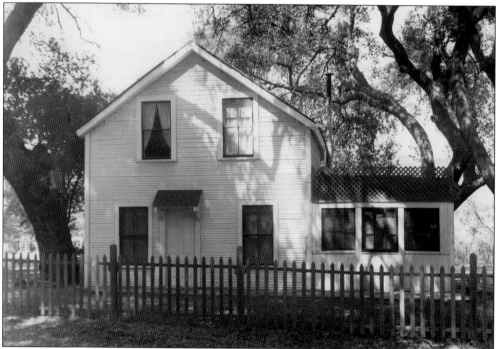

The Atchison brothers built the Atchison Toll House as a rest stop and tollbooth on the east side of Mussey Grade Road. Before the adoption of county roads, toll roads were common in San Diego County, especially in areas like this where travel options were limited by slope and geography. Situated in a grove of old oaks, the house was destroyed in the 1980s. (SDHC.)

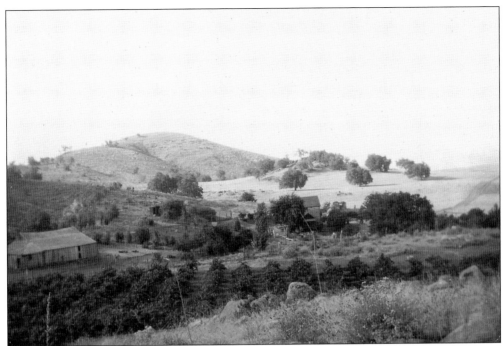

The Billingsley ranch sat between Santa Theresa and Ballena near Whale Mountain. William and Martha Putnum Billingsley settled here in the early 1870s. Daughter Martha married Zaccheus Quincey, and they settled on part of the Billingsley ranch, raising a large family. These images may be from the 1920s just after William's widow sold the Billingsley portion of the ranch. Before the area was settled by non-Indians, the 'Iipay from Mesa Grande came to this place and knew it as 'Eha Kutap. Now flooded by Sutherland Reservoir, the ranch and the ancient 'Iipay settlement rest under the water. (SQ.)

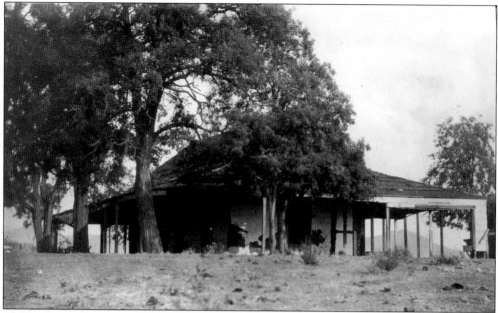

The Bernard Etcheverry adobe was an important landmark and one of the few substantial buildings on the west side of Santa María Valley for many years. Built as a much smaller and basic adobe hut sometime in the 1840s, the original building was enlarged by Etcheverry in the 1870s. While it is true that Gen. Stephan Kearny camped at the Rancho Santa María site, it was not actually in this structure.

The Etcheverry adobe fell into disrepair, as shown in this c. 1925 photograph, and may have been razed in the next year; it does not show up on 1927–1928 aerial photographs. Some local historians maintain that the building was dismantled and used for home construction in the 1930s in Highland Valley. (SDHC.)

The construction of the Amy Strong castle, beginning in 1916, was a major event in the life of Ramona with local craftsmen, including A.W. Warnock and 'Iipay from Mesa Grande, working on the five-year project. At first, the local and San Diego newspapers gave almost weekly reports on the slow progress. When completed, the 12,000-square-foot mansion rivaled those in San Diego and San Francisco.

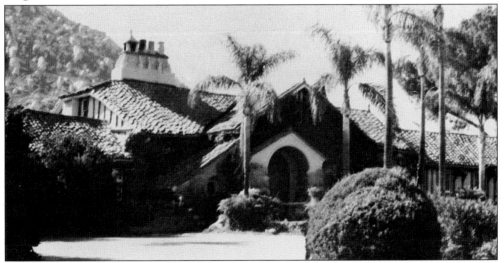

Amy Strong made a sizeable fortune in the garment-making business in San Diego. When she retired, she literally built her dream castle in Ramona. Working closely with the noted architects John Vawater and Emmor Brooke Weaver, the huge stone edifice rose from the flanks of Mt. Woodson. Invitations to the Strong castle were much desired, and events there were always described as lively and well attended. The castle is now the clubhouse for the Mt. Woodson Country Club.

Ramona! Your Future Home!
A small income, a small ranch--Happiness

BUY A SMALL ACREAGE NOW, while your earnings give you money for investment, develop your water, and when you are ready to retire, you have a Country Home to retire to or a property at a price many times your original investment.

Purchase of acreage in Ramona offers a two-fold advantage: 1. Low First Cost. 2. Opportunity to cash in on increase in value due to development and rising prices.

Take advantage of this Big Opportunity to purchase your future home and provide for your future Security.

RAMONA, HEART OF San Diego county, the Heaven on Earth Country, is so happily located as to approach the perfect in climate conditions. Twenty miles from Ocean or Mountains, it is warmed by the desert in winter and cooled by the ocean in summer! Only 20 miles from the border of Old Mexico, its winter's are sunshiny and warm. Because of the clarity of the atmosphere here the Palomar Telescope is located on a mountain top only 40 miles from Ramona.

Midway between mountains and sea, Ramona offers a diversity of recreational advantages. Bathing, Fishing, Hunting, Riding, Skiing, Mountain Climbing are among popular outdoor sports.

Ramona's healthful climate makes it the mecca of sufferers from all respitory diseases.

The population of Ramona is 99% white and American. As long as it was awarded, Ramona won the State Good Citizenship cup.

Ramona has an adequate supply of good water from wells throughout the valley. A municipal water system pumps its supply from deep in the river sands.

Here is the logical retreat for those having modest permanent incomes, where they can buy low priced land, raise their own citrus and other fruits, berries and vegetables, have a small or large flock of poultry, and live comfortably and happily. This Park, where you are now enjoying yourself, is Collier Park, donated to Ramona by the late Col. D. C. Collier, well-known San Diegan. It is one of the San Diego County Parks system and is maintained by the county.

Above the Fog Line--Below the Frost Line . Ramona Citrus has Never Been Frozen .

Ramona has always prided itself as a community of ranches, small and large. This advertisement from the late 1930s stresses the American dream of owning a piece of the backcountry for a small price. The amenities of Ramona are touted, including the climate, soils, water supply, and that it is "99 percent white and American." Perhaps more important, it is "Above the Fog Line—Below the Frost Line."

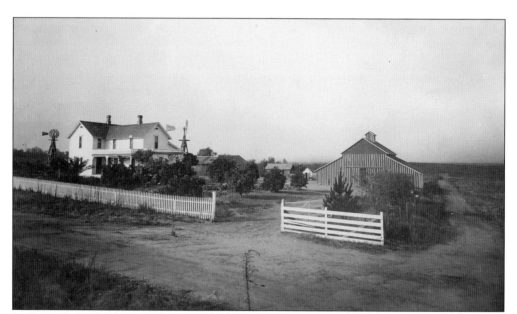

In this early-1900s photograph, the Tulloch ranch in Ramona reflects the rural ideal of the time in many ways. There is a freshly painted two-story home; a substantial barn; two windmills, including a top-of-the-line Aermotor brand; a white rail fence; and a series of outbuildings. Some young trees are bearing fruit, and the home is situated next to a maintained dirt road.

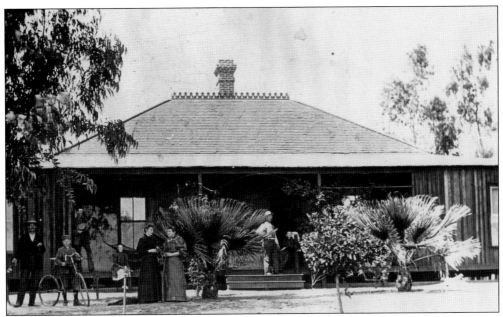

It is uncertain who built the ranch house on the sprawling Montecito ranch. Some credit Augustus Barnett, but there is no conclusive evidence in spite of knowing the various landowners over the years. What is better known is that ultimately cinema tough guy James Cagney owned the Montecito ranch and house. More than 100 years after this photograph was taken, the home still stands and is listed as a historic landmark.

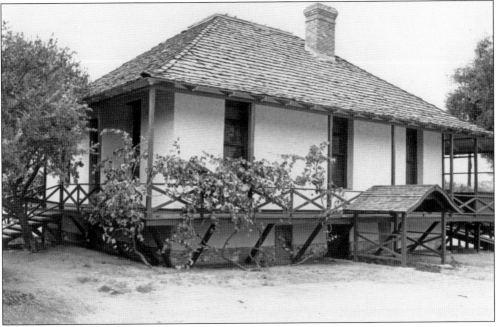

French immigrant Theophile Verlaque constructed his adobe on Main Street in 1886 as his country home away from San Diego. Verlaque owned a restaurant and winery in San Diego and also operated a sheep ranch on the edge of town. His sons Amos and Jeff ran the Verlague/Pioneer Store in Ramona. The building and grounds are now operated as the Guy B. Woodward Museum.

Ramona still has dairy cows, but throughout most of San Diego County they are a thing of the past. These contented cows are in Goose Valley at the Gene Hager Dairy around 1945. Hager and others, including Don Owen and Will Kunkler, delivered dairy products to the doors of their fortunate customers.

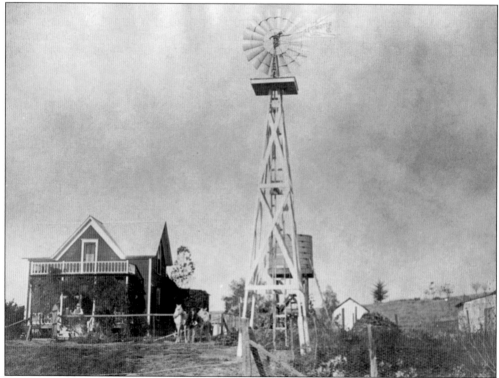

In 1902, Benjamin Pepper Jr. built this substantial two-story residence replete with an Aermotor windmill, a gravity-fed water tank, and a white fence. The person on the front porch in this 1908 image may be Mr. Pepper. The eldest son of Benjamin F. Pepper, Benjamin helped build many homes in the Ramona area and worked on the Friends Church.

One important technique for storing feed for cattle and livestock was to practice ensilage. Essentially, feed crops such as corn, clover, or oats were compressed into an airtight environment within tall silos. The sheer weight of the crops, which were added gradually, combined with a top layer of straw, compressed the vegetation into a well-preserved and easy-to-store animal food. This silo was on the Barnett ranch.

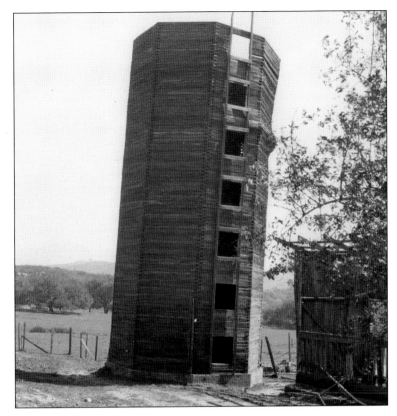

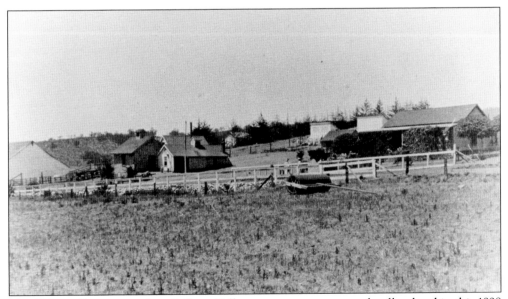

The 720-acre Rotanzi ranch in Ballena Valley appears prosperous and well ordered in this 1898 photograph. Samuel Rotanzi emigrated from Switzerland and successfully farmed and ranched at the foot of the old road to Mesa Grande. He operated one of Ramona's early dairies. At one point he was president of the State Bank of Ramona on Main Street.

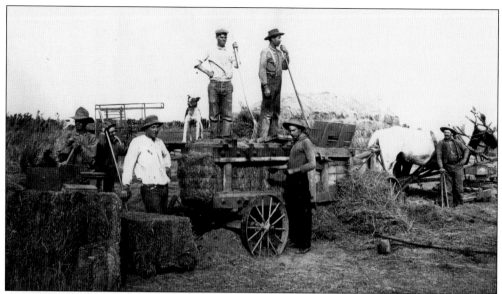

Manually baling hay has always been hard work, and in spite of few smiles these men have their work cut out for them. Ensuring a tight, dense bale was crucial. Joe Cossad is the man with the two canes to the right, and he and his crew are working in Santa Theresa Valley on Sam Warnock's ranch in 1912.

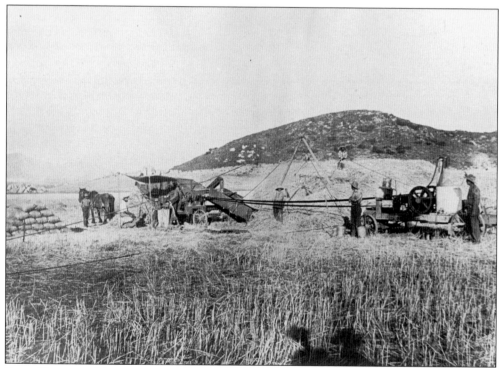

Bruce Dye, one of the many sons of John Sidney Dye, grew up in Ballena around the 1890s and 1900s. With help of an elaborate and cumbersome gasoline-driven separator, Dye and his workers are separating cereal grain from the stalks and chaff and filling burlap bags (far left) with the grain. It is uncertain in this photograph, shot in Goose Valley, which of these men is Bruce Dye.

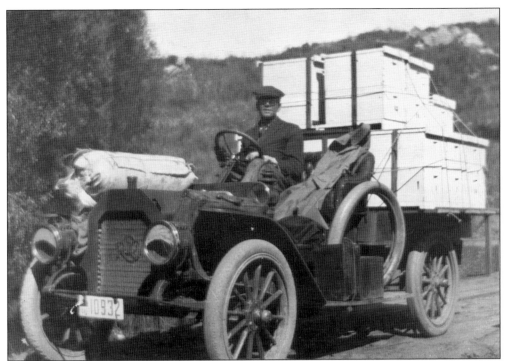

Stylish in his powerful c. 1917 REO Wagon, beekeeper Heffner has a load of hives probably on the Kieth ranch near Sutherland. It was common for beekeepers and apiarists to spot beehives in different vegetation to produce a variety of honeys such as sage or lilac. In this period, Ramona and the Harbison Canyon areas were known for the quality of their honey.

Snow is not common in Ramona proper, but heading east towards Ballena and Witch Creek a good dusting in the winter is not unexpected. In February 2008, snow fell at the lower elevations and blanketed the hills near the old Casner homestead above Hatfield Creek and the Pioneer Cemetery. Not far from here are the remains of the Casners, Littlepages, Quinceys, and Billingsleys, among others.

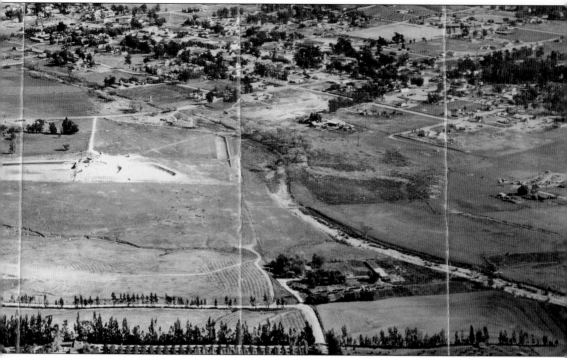

This 1934 aerial view shows the growth of the business district and the development of small farms and ranches on the outskirts. From left to right, Main Street runs at an angle across the top one-third of the photograph.

The area west of the airport and north of Highway 67 contains large parcels that have been divided into smaller ranches and orchards. At the end of Archie Moore Trail on the north, this old-style sign marks the entrance to one such ranch. Nearby Sky Valley and Highland Valley produce some of Ramona's best avocadoes and wine grapes. (RLC.)

Today Rangeland Road terminates as a public road at a gated community known as Highland Hills. The gate is near the boundary for Rancho Santa María. Within the community, Vista del Otero and the ridgeline across to Old Survey Road approximated Gen. Stephan Watts Kearny's trail as he approached his descent into San Pasqual Valley. Traces of the old carreta road remain in the grassy open space preserves. (RLC.)

Originally envisioned as a high-end mobile home park, Mt. Woodson Estates and Golf Club certainly surpasses that expectation. As a result of careful planning and the use of mature landscaping, the homes and facilities are stepped into the hill in an unobtrusive manner. This gated community encompasses Amy Strong's castle, now used as a clubhouse, and at least some of old Doc Woodson's acreage. (RLC.)

Forty years ago it was not common for large communities to be truly "planned" as a functioning unit and unusual for a builder/developer to set aside 42 percent of the land as open space. That is what San Diego Country Estates did, and it became the first such project to come under new environmental regulation with the county of San Diego. (RLC.)

Five

GETTING DOWN
TO BUSINESS

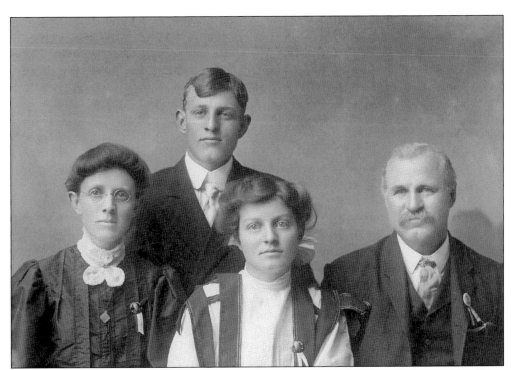

Probably no man did more to secure the future of early Ramona than John Bargar, pictured here with his wife and children. Almost from his arrival in 1891, Bargar set to as a rancher, then bought into a blacksmith shop, and finally owned a hardware store that sold most anything a rancher or farmer would need. Historian Darrell Beck said Bargar might have installed more than 400 windmills in and around Ramona.

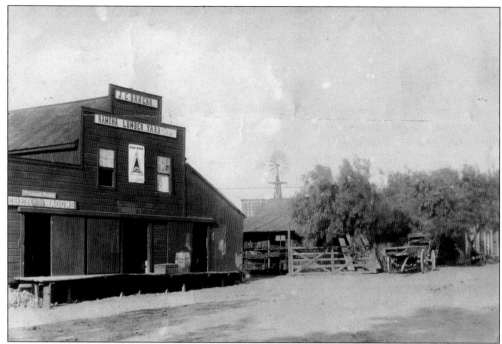

John C. Bargar built this structure as a feed and flour mill in 1896, and over three decades he expanded his business to include building and irrigation supplies. Bargar was often called Mr. Ramona because of all of his civic activities and holdings. When he opened his lumber business here in 1910, it was the first in Santa María Valley and remains a lumberyard to this day, having been purchased by Stanley and Robert Ransom in 1924.

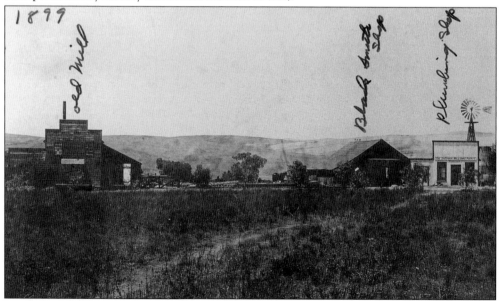

Bargar's original mill is to the left in this photograph with the blacksmith shop and plumbing shop to the right. Taken in 1899, this image captures the open lots and sparse commercialism in the immediate area of Bargar's operation. It will be several years before others join him north of Main Street.

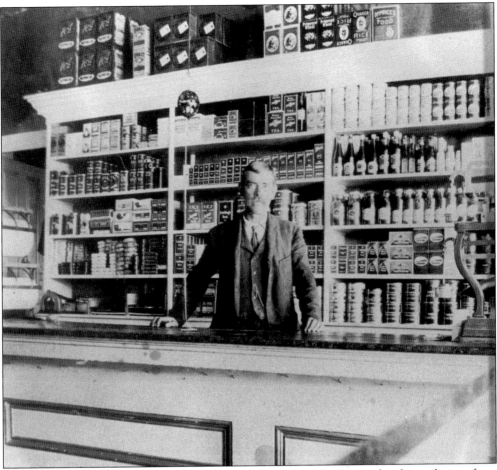

Jeff Verlaque owned and operated the Pioneer Store on Main Street that he took over from his father, Amos, around 1890. The store, originally called the Santa María Store, became the Verlaque Brothers General Merchandise and finally the Pioneer Store. Because of the canned goods and fresh produce, Jeff prospered, as shown in this 1894 image.

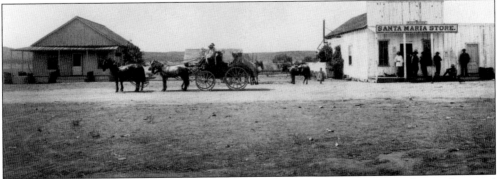

Around 1886, Amos Verlaque's Santa María Store also served as the post office and general gathering spot on dusty Main Street. The passenger stagecoach is headed west out of town, probably by way of the Mussey Grade. Out in front of the store, a group of men represent ranchers, workers, and farmers in town for the day.

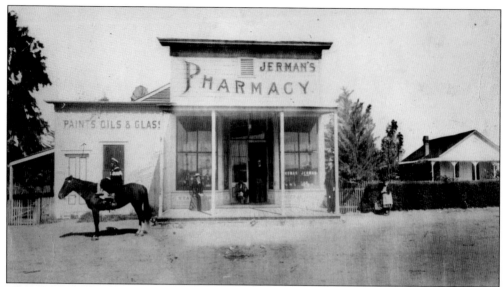

The role of a pharmacist in a rural community was part doctor, part veterinarian, chemist, and all-around healer. In 1895, Thomas Jerman's pharmacy, on the northeast corner of Seventh and Main Streets, also sold stationary and ink, fountain pens, and sundries. Thomas's son Raymond Lem ultimately took over the pharmacy. The family house is located just to the right of the pharmacy—convenient for after-hours emergencies.

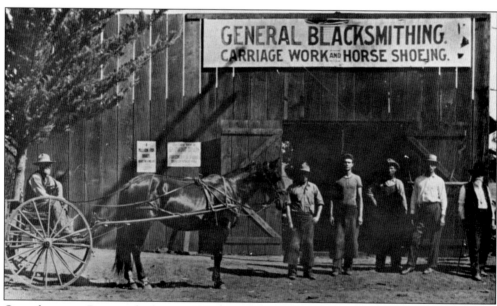

Over the years, Ramona had several blacksmiths and blacksmith shops. These men did more than forge metal and shape horseshoes, they made implements from scratch, repaired damaged metal tools, bonded chain links, and were the go-to for all things hard and metallic. This is Tim Darrough's shop in 1912, situated on the south side of Main Street in the 800 block.

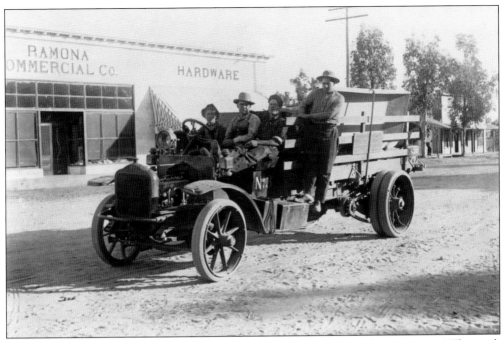

The caption on the reverse of this old photograph reads, "First Auto Truck in Ramona." The truck appears to be a straight six, has solid rubber tires, a chain drive to the rear wheels, and seems to be hauling a cement-mixing box. The sign on the side states, in part, "Cement & Pipe." The truck may have belonged to the Ramona Commercial Company. (SDHC.)

The year is 1914, and this proud driver has just pulled his Reliance hard-rubber, right hand–drive utility truck in front of the Ramona (later Kenilworth) Hotel. Hay wagons pulled by horses were a common sight on Main Street well into the 1930s, and today the descendents of this early truck still pass through town with their loads of hay.

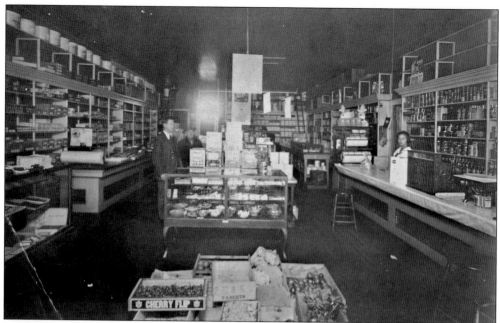

In addition to running the Valley Mercantile Company beginning in 1903, Luther Janeway also had an interest in the Pioneer Market in the 600 block of Main Street. This interior photograph of the store shows how well stocked and orderly the merchandise was. Janeway is the gentleman to the left, and his daughter Clara is behind the counter to the right. Besides fresh fruits and vegetables, the store carried a wide selection of goods, including Tabasco hot sauce and Knox Gelatin.

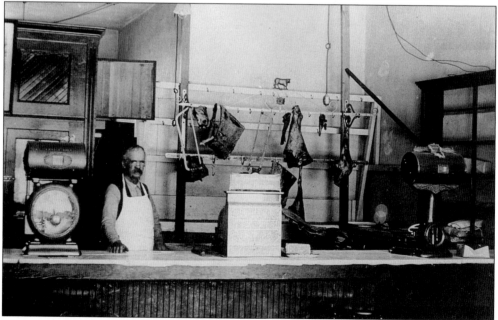

Then, as today, a reliable butcher was important to Ramona households. Elmer Booth, owner of Booth's Meat Market, filled that bill and then some. One of the sons of Ballena pioneer James Booth, he was also a carpenter and blacksmith. The interior of his shop on the south side of Main Street is shown in this 1914 photograph.

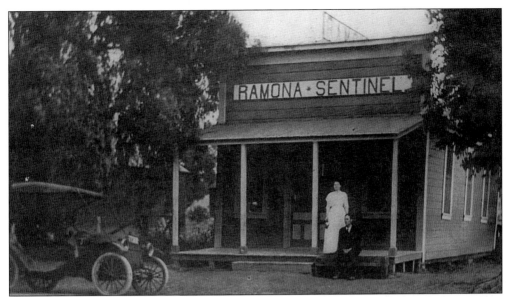

The *Ramona Sentinel* has been a community-based newspaper since its inception in 1893 by James A. Jasper, when it was known as the *Sentinel*. One of its many offices over the years was at Ninth and Main Streets, where in 1916 its owners, Timothy Brownhill and his wife, proudly pose in this photograph. Art and Ann Griffin and then their son Tom ran the newspaper from 1946 to 1982, a lifetime in the newspaper business.

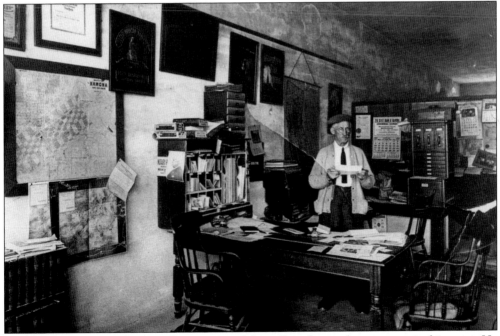

John Sutherland settled near Ballena in part of the valley where a dam now carries his name. He was a justice of the peace, notary, and sold real estate and insurance. This image of Sutherland in his office provides insight into the man and the times. Taken in the mid-1930s, he is surrounded by maps, notary books, and reams of paper. He was considered an honest man and a person who looked out for others.

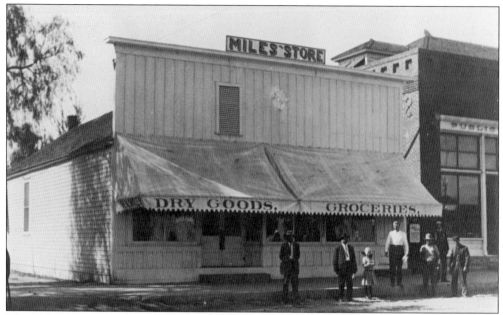

The Miles family was an important part of early Ramona's commercial success. Henry Miles bought this store on Main Street in 1899 and also the Ramona Hotel. In 1925, Miles moved the store (pictured) around the corner to Seventh Street, where it became the Grange Hall. In its place on this lot, he then built a concrete building that became the Miles Mercantile next to town hall. His son Harry served in World War I.

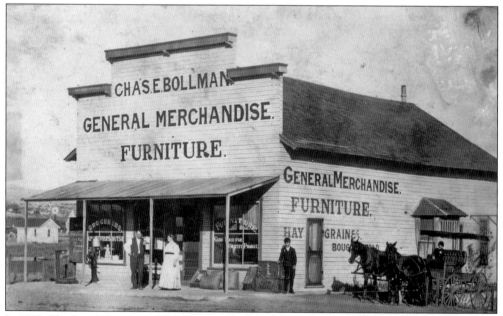

In 1917, Charles Bollman, with his store at Sixth and Main Streets, provided a little competition for the Pioneer Market and others. Bollman, who is standing outside with his wife, advertised that he bought local produce, carried the finest nuts and fruits, and also sold furniture. Not much is known about the Bollman family, but they clearly invested money and effort to bring a first-class store to Ramona.

With this headline from the October 31, 1926, *San Diego Union*, the newspaper heralded the spectacular growth of the town. With unabashed boosterism, the accompanying articles listed the major construction projects, including the Miles Store, the State Bank of Ramona, the home of William Kunkler, and the Masonic Temple. Then, as now, local real estate agents sought "down the hill" clients looking for a rural life style. (RLC.)

SANTA MARIA VALLEY CITY'S DEVELOPMENT WINS NOTICE

Ramona Spends More Than $250,000 on Residential Structures in New Growth

GENERAL EXPANSION PROGRAM STARTED

Boosters Urging 1000 Small Farmers to Enter Rich District to Share Gains.

It was a great source of pride for the citizens of Ramona to have their own State Bank of Ramona when it opened in 1926. With Samuel Rotanzi serving as bank president, the institution housed in this Romanesque building specialized in loans to local ranchers, farmers, and builders. The building also housed a pool hall and real estate office in the west wing. (RLC.)

In many communities, hotels often become a symbolic landmark of the town. Ramona was no exception, and from its construction in 1887 the Ramona Hotel, later expanded and renamed the Kenilworth Inn, was known far and wide. With the name change in 1914, probably a nod to a small village in England, and addition of a second story, the hotel prospered. Over time, it was known for its hospitality and it chicken dinners. The hotel burned in 1943.

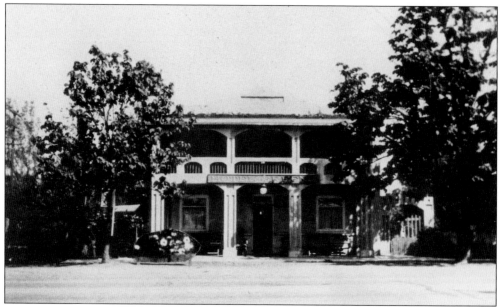

In the 1920s, the Ramona Hotel had been greatly improved and matched several of the better hotels in San Diego. A second story has been added with a long balcony, and stylish columns grace the entryway. For the next two decades, the Ramona/Kenilworth Hotel was a traveler's favorite and a special dinner place for locals. When it was destroyed by fire in 1943, it was never rebuilt.

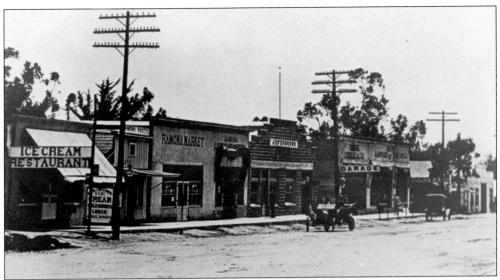

The year is 1916 and Main Street remains unpaved. Automobiles are starting to make their appearance, often parked next to hitching posts. The ice cream parlor to the far left will change into the Turkey Inn in 1938, businesses will come and go to meet the needs of the community, and ultimately streetlights and a paved road will be important milestones. Stoplights are still decades away.

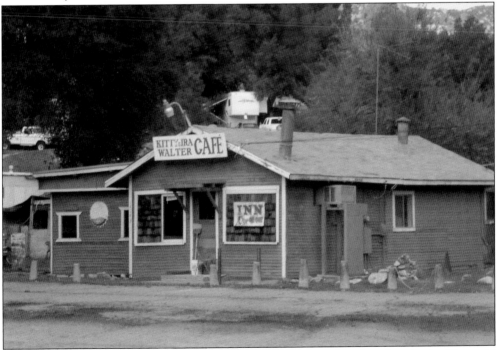

There was a time when hunters, fishermen, and folks seeking solace from hectic city life would make the trip down Mussey Grade Road to Kitty's Cafe. Built sometime before the 1930s, this old-style roadhouse was owned and operated by Ira and Kitty Walters. From 1943 when completion of San Vicente Dam made the lake a favorite fishing spot to the closure of the northern access to the lake via Mussey Grade in the 1960s, the cafe had its heyday. (MGRA.)

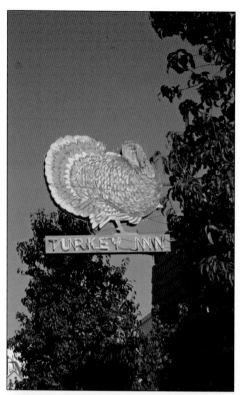

In 1917, at the site of an ice cream parlor, Ramona's first street lamp was lit. For decades after a large sign depicting a neon-lit turkey was hoisted over a modest cafe and bar on Main Street, one might hear, "Meet me at the Turkey Inn." With its license to sell alcohol in 1938, the Turkey Inn became a local legend and was open until 2:00 a.m. seven days a week. (RLC.)

For a decade, beginning in 1907, telephone companies owned this parcel and building. John Bargar purchased the lot in 1921, erected this building in 1929, and leased it to the Pacific Telephone Company. Carrying on the theme of telephones, the McWhorter Restaurant and Old Telephone Company Restaurant operated in this triple-arched Spanish Revival stucco building through the 1980s. (RLC.)

In the years before the temperance movement gripped Ramona, Isaac Green built this structure on Main Street and opened a saloon. With the adoption of Prohibition in 1919, thirsty cowboys no longer tied their horses to the hitching post that once graced the front. John Bargar bought the structure in 1923 and expanded it on both sides; in later years the Newman Clothing Store operated here. (RLC.)

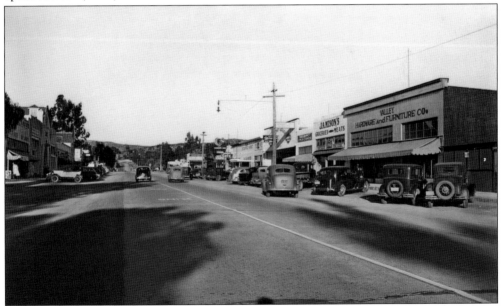

By 1938, when this photograph was taken looking east down Main Street, the town was all grown up. Valley Hardware and Furniture, Jamison's Meats, the Enterprise Market, the Ramona Cafe, and the Turkey Inn, with its brand-new iconic sign, can be seen on the right side of the street. A.C. Bisher's garage is open for business, and slant parking was still in use on Main Street. (SDHC.)

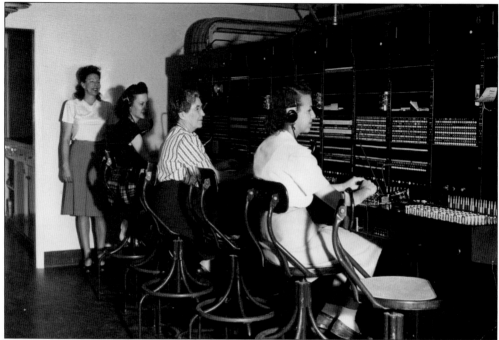

In 1948, Ramona was high tech with four switchboard operators handling the calls for a growing community. Until 1967, telephone service was via a party line, meaning that subscribers would share their line with up to eight other subscribers. While there were rules of etiquette sharing lines, some folks were more polite than others.

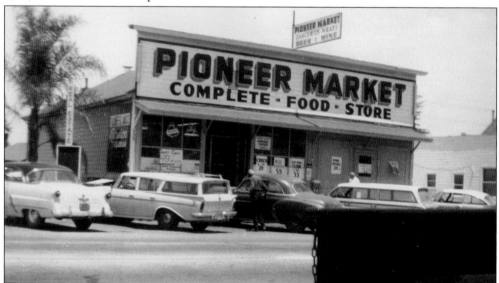

Still in business around 1956 when this photograph was taken, the Pioneer Market had been serving the Ramona community for more than 70 years. The building has appeared largely unchanged over the years. Prices, however, were another thing: MJB coffee sold for 59¢ a pound, Gold Medal flour was 53¢ for five pounds; and fresh pork sausage sold for 39¢ a pound. While these prices might have stunned an earlier generation of shoppers, the average annual working wage was $3,851.

Six

FUN IN THE VALLEY
OF THE SUN

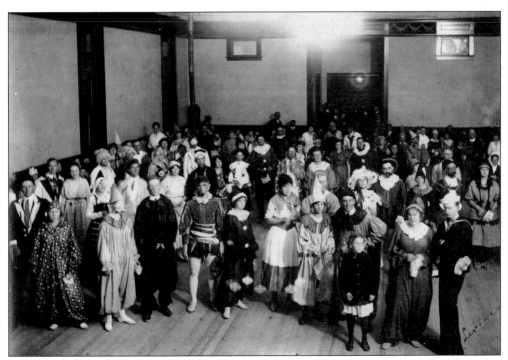

The event is the 1918 Masquerade Party at town hall—clearly there was a medieval theme. Many of the revelers are holding masks to be donned later, although the sailor will still look like a sailor when he puts on his mask. The town hall was used for plays, dances, assemblies, religious meetings, and conventions.

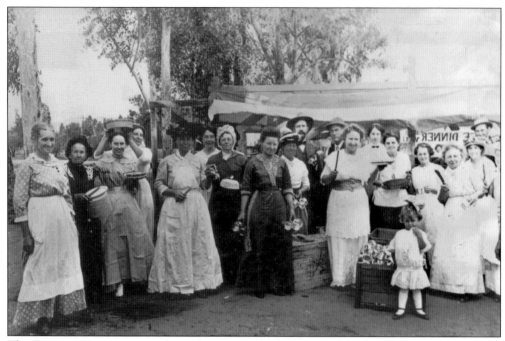

This Ramona Day picnic on November 7, 1914, looks like a good time. Several generations of ladies have brought an assortment of pies and cakes, which they proudly show to the camera. Dinner was free to the community, although everyone was expected to pitch in. The woman in the center is holding shiny new tin cups, probably from the bin situated behind the little girl on the right.

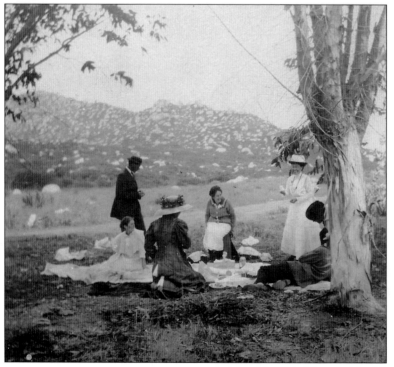

Picnics in the country were always a great diversion, even for those who were not from the city. These well-dressed folks appear to be taking a break from their meal. This area near San Vicente Creek was a favorite picnic area and is located just southeast of the intersection of San Vicente and Wildcat Canyon Roads.

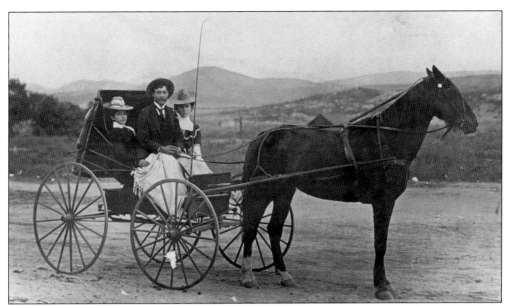

Posed here on the edge of town in 1898, Robert Green is out for a ride, with Mabel Poole on his left and Mary McIntosh on his right. Buggy rides were a common form of entertainment and relaxation and allowed a chance for the younger folks to get away from adults for a while. Green worked as blacksmith in the early 1900s and helped to repair buggies and later automobiles.

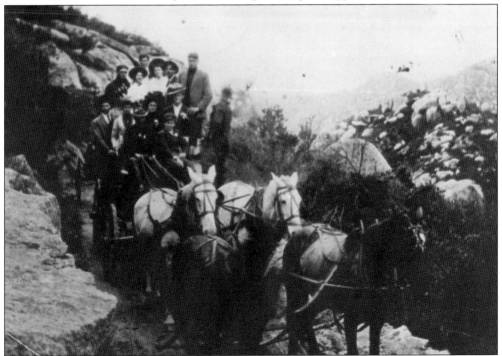

Team travel in 1908 was a little different than it is today. Having played an exciting baseball game against their rivals in Ramona, the Poway team and their supporters are making the arduous trip home down the Poway Grade. It is hard to say if they won or lost, but the entourage appears happy.

"Near to Nature's heart."

Tenting Under the Live Oaks at

Ramona Tent Village

FOR your summer vacation, go to **Ramona Tent Village,** located in the grandest live-oak grove in Southern California, at an elevation of 1500 feet. The change of altitude will do you good. Tents either furnished or unfurnished, with floors and half walls, or plain, are now ready. First-class restaurant on the ground. All kinds of amusements, saddle ponies, etc. A perfect freedom from mosquitos, fleas and rattlesnakes. Pure mountain water and wood free. Ground free to those bringing their own tents.

Special through rates from San Diego to Ramona Tent Village. Comfortable conveyance meets stage daily at Ramona

Furnished Floored and Boxed Tent, with board—per Day	$ 2.00
" " " " " " " —per week	12.00
" " " " " " " —per month	40.00
" " " " } " without " double bed, day	.50
" " " " " " " week	3.00
" " " " " " " month	12.00
Each additonal bed, 35 cents extra.	
Furnished Floored Tents—per day	.35
" " " " week	2.25
" " " " month	8.50
Camp Style, Furnished Floored Tent, double bed—per day	.35
" " " " Tent, double bed—per week	2.25
" " " " Tent double bed—per month	8.00
Plain Tent, unfurnished, no floor—per day	.25
" " " " —per week	1.50
" " " " —per month	6.00

All canvas 6 foot wall tents same price as box tents.

SINGLE MEALS, 50 cents. 21 Meal Ticket at reduced rate. Stable on the ground.

For particulars see Diamond Carriage Co., 957 Fourth street. For further particulars and literature, address—

T. P. CONVERSE,
RAMONA, CAL.

Advertisements for the Ramona Tent Village appeared in the *San Diego Union* and the *Los Angeles Times* during its heyday from 1903 to 1907. The ads promised no rattlesnakes, fleas, or mosquitoes; clear fresh water; free firewood; and camping under the oaks. Meals could be provided, as well as riding ponies. Transportation to Ramona from San Diego was by way of the Diamond Carriage Company.

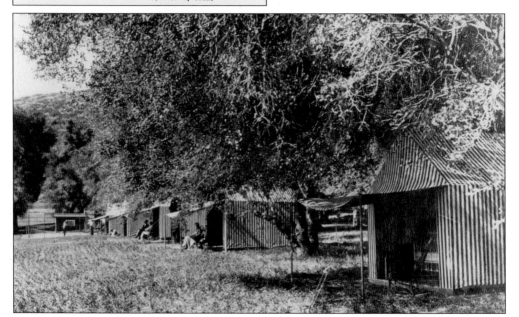

In this undated photograph, happy campers can be seen relaxing outside of their striped tents under the shade of old oak trees. For the more active, there was a tennis court and hiking trails. In the early 1900s, city dwellers increasingly turned to the backcountry for rest and recreation in keeping with the establishment of national parks and forests. (SDHC.)

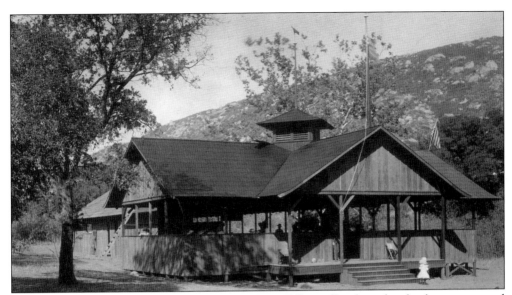

The office and covered pavilion at the Ramona Tent Village offered supplies for the campers and a place to gather. Dances and sing-alongs were also held here. J.P. Converse of San Diego ran the successful operation. Following the San Francisco earthquake in 1906, Converse sent tents and equipment to the city as part of a statewide relief effort.

Nestled back in a valley off Mussey Grade, a camp catered to families and friends who wished to enjoy nature without the hindrances of clothing. Known initially as the Pow Wow RV Park and from the 1960s to 1980s as Camp Samagatuma, the recreational facility gained worldwide fame even hosting Miss Galaxy Nudist events. Today the camp is an RV park with cabins and small homes. The old "S" on the mailbox, pool, and clubhouse remain—but clothing is now always required. (RLC.)

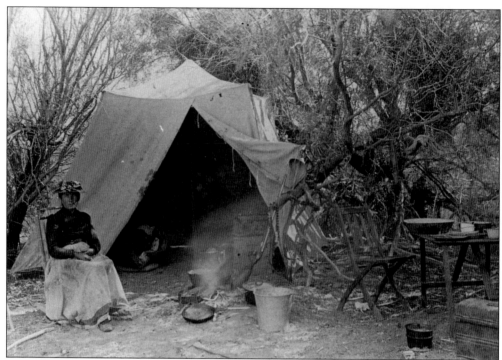

Somewhere in the backcountry, Mrs. Stephen was captured on film by a camera, probably held by Frank Stephen. A fire is smoldering, a shotgun leans against the canvas tent, metal cups and plates are laid out on the folding table, and a bean pot rests on the ground. This is clearly a couple that has camped before.

In 1917, Mrs. W.O. Sanford took part in a war bond drive at Mussey's Pleasant Grove. Even though most Americans were reluctant to enter "Europe's War," when President Wilson declared war on Germany, patriotism outweighed provincialism. Whether the automobile is decked out in a vegetal type of camouflage or some other backcountry design scheme is uncertain.

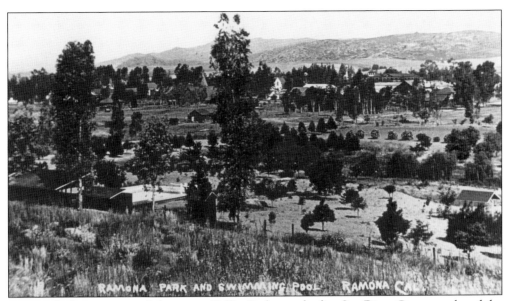

Ramona Park, more correctly known as Collier Park, was the first San Diego County park and the first in the county to have both a children's and adult swimming pool. D.C. Collier, who owned a ranch along the Hatfield Crossing, donated the land in 1913 requesting that the county provide maintenance. The park was formally dedicated in 1915. Paul Thiene, the landscape architect for the Panama-California Exposition, planned the landscape design.

One of the tasks of the Civilian Conservation Corps (CCC) in Ramona was to build flood-control culverts, drainage channels, and small bridges. Collier Park was already a well designed and much used park when the CCC was tasked in 1934 to construct rock culverts, bridges, and walls within the park. These intricate yet rustic stone features contribute to the natural feel of the park. Many visitors are unaware of the historic value at their feet. (SDHC.)

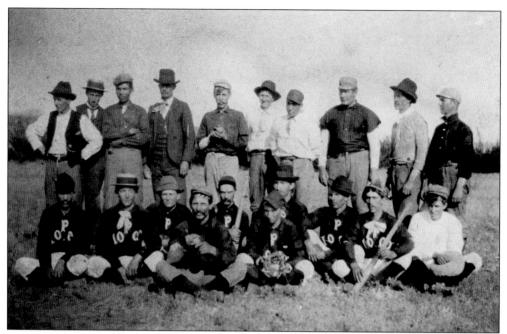

Baseball has always been America's pastime, and that was certainly the case in the late 1890s and into the 1900s. This group of Ramona players played in a true dead-ball era when mitts were thin and small and the spikes were metal and sharp. Ramona played teams from Poway, Julian, Escondido, and Lakeside.

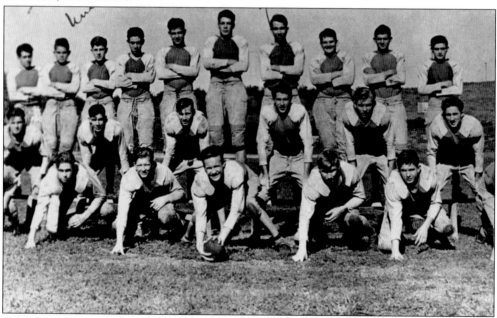

Skip ahead more than 40 years, and the Ramona High School football team of 1940 appears ready to play. Within a year or two, many of these young men would be in the military and fighting World War II. Sadly, Bobby "Angelo" Latta (standing, second from right) and Archie G. McArthur (crouching, third from right) were killed in the war. The Ramona VFW is named in honor of McArthur.

In this evocative image, girls from Ramona High School are seen having a spirited basketball game. The year is 1915 and the dress code dictated long, loose skirts, long stockings, and head wear. The court may be hard-packed earth with lines chalked rather than painted on the surface. The crowd includes women in stylish hats, men in suits, and classmates. Parking at school events clearly was not yet a problem.

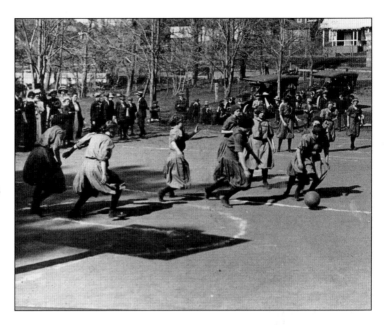

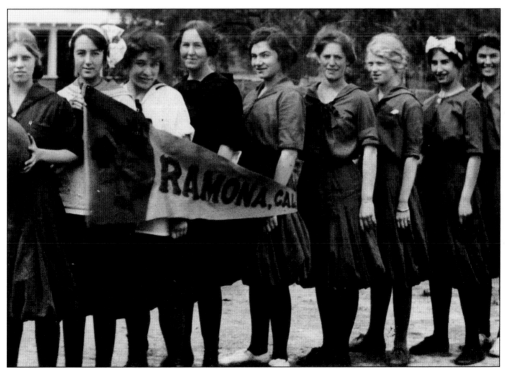

Although the student body at Ramona High School was relatively small until the 1950s, the school produced fine athletes of both genders. For some of their competitors, the Ramona "farm girls" were a formidable force. The 1915 women's basketball team was a talented team with, from left to right, Lila Boggs (fourth), team captain Bessie Haworth (fifth), and Anna May Sutherland (sixth).

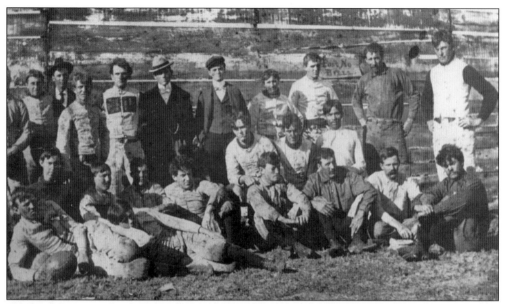

While enthusiastically played and supported in the 1890s, football was not as popular as baseball. In this 1898 photograph, the adult Ramona Football Club poses for a team portrait. Moustaches were obviously in style, as was a full head of unkempt hair. The shape of the football itself was still evolving, with the pigskin on the far left not as pointed as today's balls.

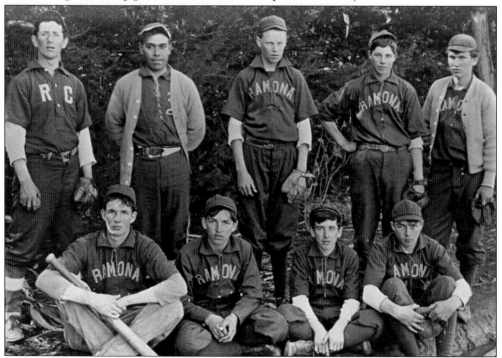

The 1911 Ramona High School baseball team may not have all had matching uniforms, but they played with hustle and spirit. Baseball had always been a big part of Ramona life well before the Little Leagues and youth baseball movement came on the scene. All that was needed was a semi-level field, a bat or stick, a ball, and some form of a mitt. Play ball!

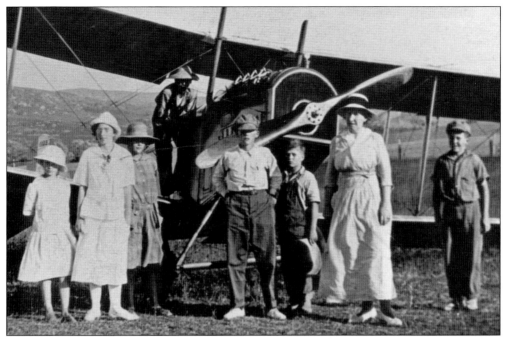

This World War I–era biplane was apparently set down in a grain field near Pile and Pamo Roads, drawing a crowd. Pictured are the Hinshaw children with Elmer (on the wing), Birdie (third from the left), and Cecil (fourth from the left). The others are unidentified, but the visit may be an impromptu school field trip with their teacher in attendance.

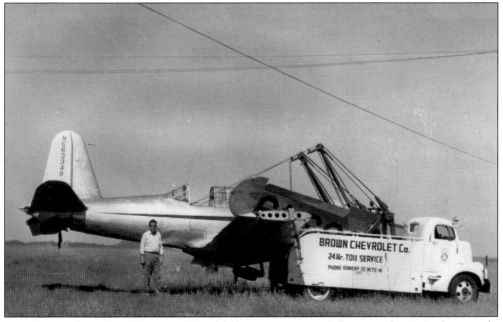

Don Brown Chevrolet of Ramona offered full-service towing, as shown in this 1954 photograph. Plane NC63349 apparently made a hard enough landing in a field to severely bend its landing gear and damage the tail and wings. As noted on the truck, one need only dial 35 during the day or 41 at night to contact Brown's shop.

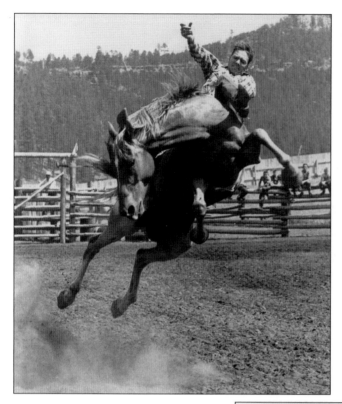

Caught in action in 1953, Casey Tibbs held the title of world rodeo champion for many years and may be the best-known rodeo star of all time. In the 1970s, he leased a portion of the old Burton Bassett ranch (now the Bassett Preserve) and ran cattle there. As Ray Watts began to develop the surrounding lands for San Diego County Estates, Tibbs helped promote the development with exhibitions and autographed photographs.

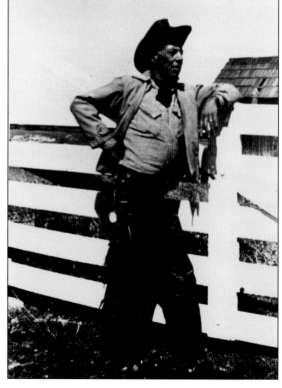

Lloyd Swycaffer came from a long line of ranchers. His grandfather Joseph Swycaffer homesteaded in Ballena Valley in the 1850s after leaving the army. Lloyd's father was reputed to be the first white baby born in Old Town and ultimately took over the family ranch. Lloyd and his brother Alonzo were noted riders and ropers—talents that got them roles in several Western movies.

In the 1940s, the Cowgirls Fancy Riding circuit had three major stars: Faye Blessing, Edith Happy, and Mabel Strickland. In this action shot, Faye Blessing performs one of her famous stunts while her horse charges ahead at a gallop. Injuries were part of the job, but Blessing was more fortunate than most and for more than 10 years thrilled national and international audiences.

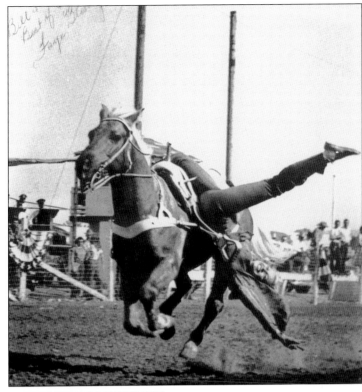

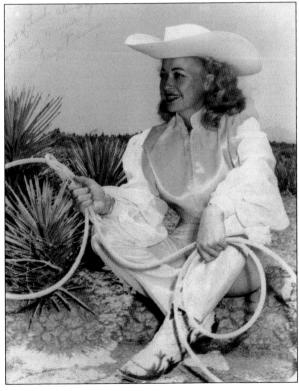

Perhaps not as well known as Casey Tibbs, Faye Blessing was nonetheless a star in her own right. She also worked in Western movies and on television as a stunt double for Dale Evans and other female stars. In this posed shot after she had retired to Ramona in 1978, Blessing is smartly dressed with her signature custom-made cowgirl boots.

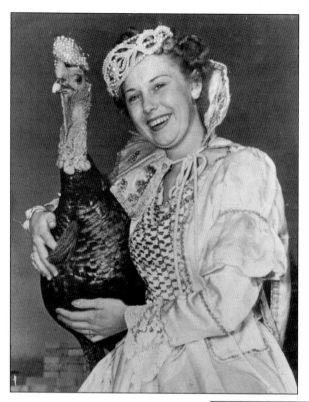

The Turkey Day Queen for 1938 was Dottie Richardson (McIntosh). Turkey Day began in 1933 as a way of promoting Ramona's growing turkey industry. The first queen in 1935 was Gertrude Page (Wilson), and the last queen was Kay Kendall (Brister) in 1941, when World War II brought an end to the tradition.

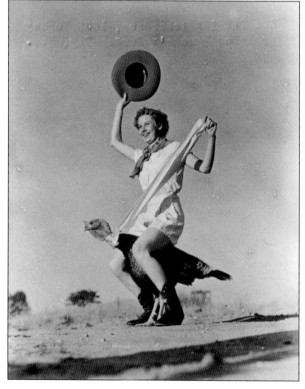

Ride em' cowgirl, or in this case, "turkeygirl." Always game for a photograph opportunity, Queen Dottie Richardson puts the stirrups to her turkey mount and raises a hat in salute. This photograph was widely circulated in the backcountry press, as well as "down the hill" in San Diego and nationally. Tom the turkey seems to enjoy the attention.

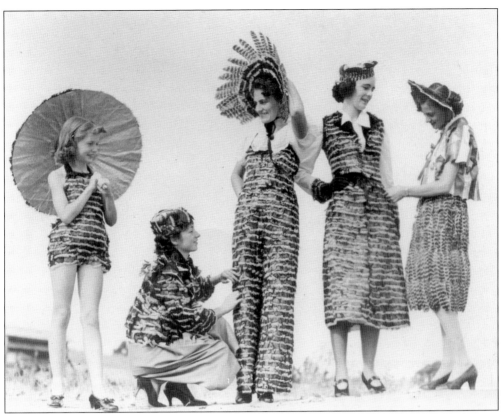

When Mary Kay Kearney married A.P. Holly, a local turkey rancher, she came up with the idea of using turkey feathers for clothing. In 1937 and 1938, the feather robes, hoop skirts, and even doggie jackets caused quite a stir. The photographs of Mary Kay Pinkard in feather formal attire made national news. In this photograph, Mary Kay is third from the left.

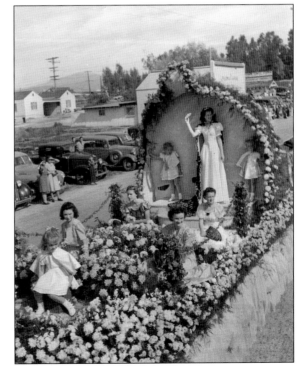

In 1940, Turkey Day had expanded even more to include a parade with large floats and a queen with quite the retinue. Queen Teddy Riddle (Klatt) and her court glide down Main Street in regal form. The parades drew thousands of spectators from throughout San Diego and Riverside Counties.

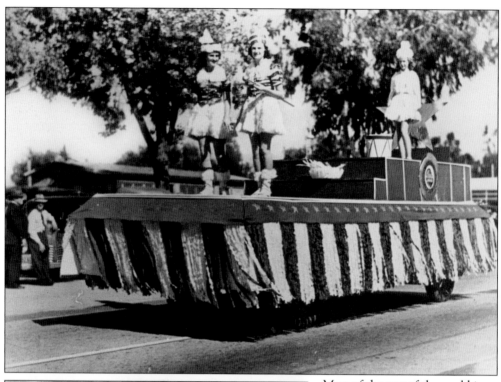

Most of the rest of the world is at war, but in sunny Ramona in 1940 the Turkey Day parade rolls down Main Street. Astride this float are Mary Kay Kearney (front left)—already known for her turkey feather gowns and dresses—Georgina Kearney (front right), and Ada Matlack (rear). The Turkey Day parade and festivities would be enjoyed for one more year in 1941 and then terminated because of the war.

Ramona has a long history of selecting local young women as symbols of the community. There have been Miss Ramonas, a tradition common with other towns and cities, but few communities have a Miss Rodeo and even fewer, if any, have had Turkey Day Queens. In 1988, Angie Thompson proudly earned the title of Miss Ramona Rodeo.

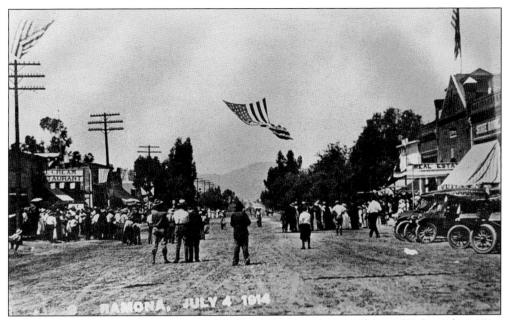

In the early 1900s, most communities, especially rural communities, celebrated Independence Day with a grand flourish. On the Fourth of July in 1914, the place to be was Main Street, and the activities were plentiful, including a civic parade, pie eating contests, and horse races. Captured on film in this instance is the annual sack race with two boys heading east towards the finish line. Perhaps cold ice cream from the store on the left was their reward.

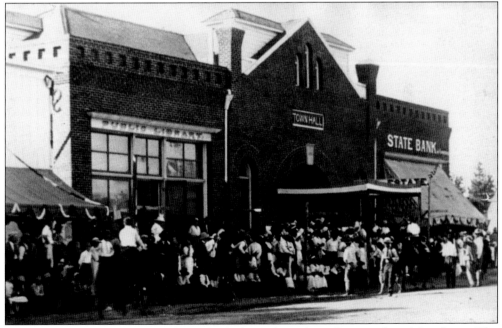

It is the Fourth of July in 1920 and time for the big Independence Day parade on Main Street. The town hall is dressed in red, white, and blue bunting, the street has been swept and watered, and anticipation is growing. Parade participants would have included civic groups, veterans, school bands, and dignitaries waving from the backs of shiny automobiles. (RLC.)

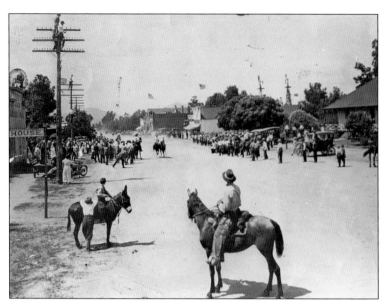

Horse races were run on improvised ovals, down country lanes, and in this case up Main Street. The finish line on this Fourth of July was the power pole on the left, upon which a few boys have a great view. Notice that there are a few automobiles parked in front of the Verlaque House to the right and that the American flag flies from several poles and buildings.

Francis Green built the Ramona Hotel in 1914, and like many buildings in the area, Clarence Telford served as the contractor. Behind the false "Western" front, the building is a stucco structure that once had an arched facade. Originally a rooming house, it became the Green Hotel and then the Round Up Hotel in the 1960s. Over the years, the building has had many functions besides being a hotel, including housing a jewelry store and an art gallery. (RLC.)

In the era of these young men's fathers, it was against California law for Indians to own rifles and guns. By the 1880s, those prohibitive laws had been repealed. Game hunting for many 'Iipay at Mesa Grande, as well as for nearby ranchers, was for both sport and meat. While deer were favored, rabbits, hares, and quail were more commonly bagged.

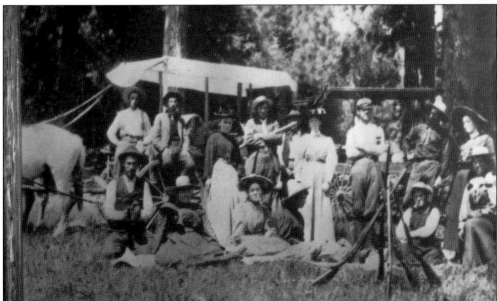

This large camping party has set up camp in the Doane Valley on heavily wooded Palomar Mountain. Certainly more than a day trip in 1897, the intrepid families represented in this photograph include the Woods, the Peirces, Stocktons, and Gibbs. Note that their guns and rifles are stacked military style and that among the 16 campers there was certain to be an experienced hunter or two.

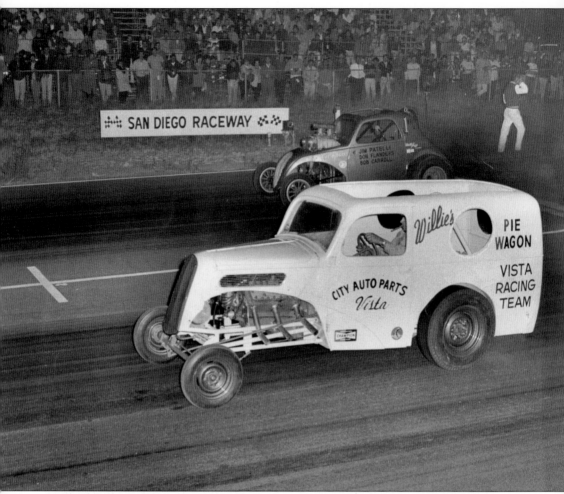

From its grand opening in 1963 and until 1966 when it could no longer compete with the more modern Carlsbad Raceway, the San Diego Raceway, later the San Diego Dragway, served as a main venue for nationally ranked drag racers. Attendance varied from 4,000 to 7,000 on a Saturday or Sunday, with special events drawing even larger crowds. Willie's Pie Wagon from nearby Vista wowed the fans. (SC.)

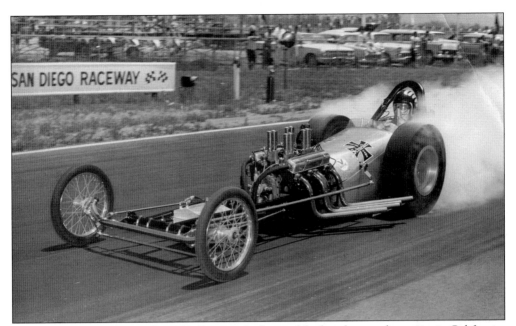

It is hard to believe that in the 1960s Ramona had one of the best-known drag strips in California. Paul and Bob Darrough leased land from the county near the Ramona Airport, and Lou Castenagna and Ray Richards came in as managing partners. Andy Smith, a strong advocate of getting youth and their hot rods off the streets, worked as the track announcer. (SC.)

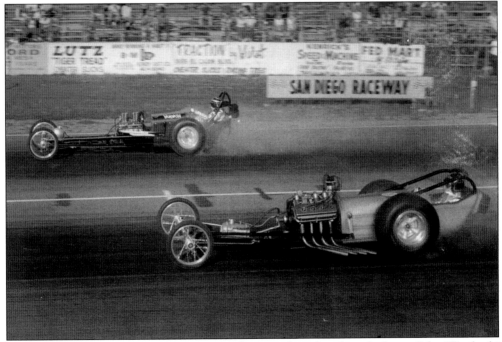

The San Diego Raceway had an impressive safety record until sixth-ranked racer John Wenderski crashed his dragster in February 1964 and was killed. There was always an element of danger, as these two competitors are racing side by side at speeds up to 180 miles per hour. The Horvath brothers of Solana Beach were crowd favorites, and their car is closest to the stands. (MAC.)

One of the perks for Miss Ramona was apparently to be photographed on fire engines. In this case, the lucky lass is Linda Thompson around 1958. Engine no. 3 of the Ramona Fire Protection District, formed in 1946, had already seen a few years of service when this photograph was taken.

Jennifer Lynch came to her 1985 Miss Ramona title by way of a grandfather who settled off Mussey Grade in the 1930s, her mother, Alice, who was a well-loved local schoolteacher, and a few months spent living at the Samagatuma nature camp in the early 1970s. The Miss Ramona pageant remains popular and well attended, as does the Miss Ramona Rodeo Queen event. (RLC.)

The Ramona Band of 1928–1929 included Bruce Telford (on clarinet, fourth from left), Dick Berry (on the far right), Estel Sherwood Kelly, and on her right Ed Deffenbough. The band was in great demand to play at local dances, parades, and other civic functions. In the days before television, live music by local groups was a good draw, and these musicians no doubt got to play the tunes of the day—maybe even a little Cab Calloway.

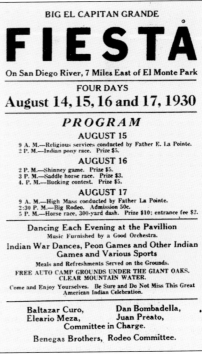

In the early 1900s, it was an annual event for non-Indians to make a trek to one of the reservations for a fiesta. As shown on this poster, a variety of events were held. In 1930, the 'Iipay of El Capitan held their well-known fiesta, one of the last before they were removed to the new Barona and Vieajs Reservations. The El Capitan Reservoir now covers their lands. (RLC.)

Still serving as a major entertainment venue for Ramona, the recently renovated Ramona Theater is a classic art deco style from 1947. Built by Frank Beck for Robert Bivens and Jude Poynter, the opening of the theater had been delayed by materials shortages during World War II. In the 1970s, the theater was converted to a multiplex, and most recently it has been reopened by Orrin Day as the Ramona Main Stage nightclub. (RLC.)

The Boy Scout Camp at Mataguay has been an institution for boys throughout San Diego. Many Ramona boys have fond memories of this oak-shrouded campground on the road to Warner's. For the 'Iipay, the valley was an ancient source of a gray or white clay that was used in the fire dance and other rituals and from whence the name evolved meaning white clay earth. (RLC.)

Today buggy and cart rides are mostly for fun, but as seen earlier they were once a major form of conveyance in Ramona. This mini-cart provides the riders with a sense of the old days without a surrey on top. (CT.)

With more than 25,000 horses stabled in the Ramona area, little girls do not have to go far to visit and ride ponies. This young lady is enjoying a birthday party at the Prancing Pony on the west side of town, where many a youngster gets their first real pony ride. (CT.)

One of the advantages of living in Ramona is either growing up or working in a community that is still largely rural. In this instance, a trainer at the Prancing Pony works with the animals she loves and gets to share her passion with children of all ages. All the little cowgirl knows is that she indeed has her "little pony" under her and a slow gait is fine. (CT.)

The days of Ramona's reign as "Turkey Capital of the World" may be over, but the area still supports plenty of poultry ranches and backyard birds. Here a few young ladies meet the acquaintance of some hens and roosters. The 4H and Future Farmers of America programs are strong in Ramona, and local youth make a good showing every year at the San Diego County Fair. (CT.)

Near the intersection of Archie Moore and Highland Valley Roads is one of Ramona's greatest assets, the Ramona Grasslands Preserve. With more than 2,000 acres of open space, the preserve contains a wide variety of biological and natural resources, cultural resources, and riding/hiking trails. The acreage includes portions of some of the older ranches, old carreta and wagon roads, and guided hawk watches. (RLC.)

Throughout the West, cowboys and cowgirls are as likely to wear a baseball cap as a Stetson. In an interesting example of mixed land use and compatibility, this rider is checking on his cattle within earshot of the Ramona Airport. A combination of a no-build zone, spray fields, and a grasslands ensures that range cattle still have a home off of Rangeland Road. (RLC.)

The horses are enjoying the peace and quiet, but a good ride could be in their future. The Ramona Trails Association is an all-volunteer organization that promotes trails, riding, and the outdoors experience. The annual Ramona Rodeo in May of each year draws high levels of competition for both the horses and their riders. (RLC.)

While sometimes a point of contention and rancor, Ramona is home to some important, and endangered, vernal pool systems. These ephemeral bodies of water support plants and animal species that require a very specific habitat. The pools in this photograph no longer exist, having been replaced by a grocery store and apartments. Through careful planning, land can be developed while preserving both habitat and open space for the future. (GWP.)

The view from the Ramona Grasslands Preserve just above the Santa María Creek is unequaled. Within minutes of Main Street, the preserve shows the best of what the backcountry can be when agencies, landowners, and citizens work together. (RLC.)

This scene, three days after the October 2003 Cedar Fire, tells a story of destruction that would only gradually lead to renewal. With many areas of backcountry Ramona cloaked in brush and chaparral that had not burned since the 1930s, the flames found substantial fuel. When the firestorm was over, more than 280,000 acres had burned, 2,232 homes had been lost, and 15 fatalities were recorded. (RLC.)

One does not have to go far some days to view Ramona's wild side. This 25- to 30-pound bobcat frequents the hills and canyons south of Mahogany ranch in the protected open space there. Mountain lion sightings are less common, but not unheard of, especially in the interior canyons. The Cedar Creek and Witch Creek fires destroyed habitat that is only now growing back. (RLC.)

4th Annual
TURKEY DAY

Sponsored by

Ramona Turkey Growers Association

in Conjunction with

4H CLUB VALLEY FAIR

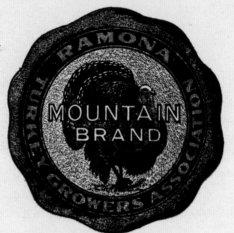

The Seal of Quality

COLLIER PARK
Ramona, California
November 7, 1936

DEMAND "MOUNTAIN BRAND" TURKEYS

The Ramona Turkey Growers Association made every effort to ensure that their turkeys and turkey eggs were not confused with brands from outside the area. By labeling the turkeys "Mountain Brand" and applying that symbol to everything from turkey wrappers to parade floats and giveaways, the producers got their message across. The growers were also big supporters of 4H programs, as are current farmers and ranchers.

As one approaches Ramona from the west, the intersection of Dye Road and Highway 67 boasts a large art installation that welcomes people to Ramona, the Valley of the Sun. Through the efforts of Arvie and John Degenfelder and many others, this icon of the community reflects the hills, horses, valley, eagles, and wine grapes that symbolize Ramona in the 21st century. (RLC.)

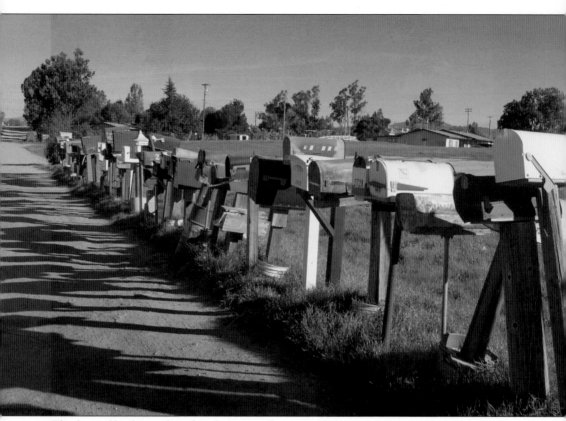

The line of both weathered and new mailboxes on Hope Street serves the many families who live back in this enclave known as "The Acres." Not far from the end of this dirt road is where pioneer Bernard Etcheverry built his home and began the process of creating the community now known as Ramona. Etcheverry would be proud to know how the little village of Nuevo grew and prospered, although the traffic on Highway 67 might be a challenge. (RLC.)

BIBLIOGRAPHY

Beck, Darrell. *On Memory's Back Trail: A Story History of Ramona and the Backcountry of San Diego County.* Carlsbad, CA: Backcountry Press, 2004.

Bowen, Russell and Leona B. Ransom, ed. Ruth S. Myer. *Historic Buildings of the Ramona Area.* Ramona, CA: Ramona Pioneer Historical Society, 1975.

Carrico, Richard L. *Strangers in a Stolen Land.* El Cajon, CA: Sunbelt Publishers, 2007.

Carrico, Susan H. and Kathleen Flanigan. Ramona Historic Resources Inventory. San Diego: County of San Diego, 1991.

Davis, Edward. Field notes on file at the San Diego History Center, San Diego.

Harrington, John P. Field Notes for the Diegueño Indians, San Diego. Smithsonian Institution, National Anthropological Archives: Suitland, MD.

Le Menager, Charles. *Ramona and Roundabout.* Ramona, CA: Eagle Peak Publishers, 1989.

Ramona Sentinel (1893–1955). Guy B. Woodward Museum, Ramona, CA.

www.arcadiapublishing.com

MAP SEARCH

Discover books about the town where you grew up, the cities where your friends and families live, the town where your parents met, or even that retirement spot you've been dreaming about. Our Web site provides history lovers with exclusive deals, advanced notification about new titles, e-mail alerts of author events, and much more.

MADE IN THE USA

Arcadia Publishing, the leading local history publisher in the United States, is committed to making history accessible and meaningful through publishing books that celebrate and preserve the heritage of America's people and places. Consistent with our mission to preserve history on a local level, this book was printed in South Carolina on American-made paper and manufactured entirely in the United States.

This book carries the accredited Forest Stewardship Council (FSC) label and is printed on 100 percent FSC-certified paper. Products carrying the FSC label are independently certified to assure consumers that they come from forests that are managed to meet the social, economic, and ecological needs of present and future generations.

FSC
Mixed Sources
Product group from well-managed
forests and other controlled sources

Cert no. SW-COC-001530
www.fsc.org
© 1996 Forest Stewardship Council

Find Your Place in History.